Kimonos

Rinko Kimino has written 20 books on kimonos, Japanese folk craft and kabuki and her work has appeared in several books, magazines and newspaper articles. Her works are geared toward the youth of Japan, and promote Japanese traditions and crafts such as kimonos with a modern sensibility. As a curator of Japanese culture, she wants to share with and educate others on the beauty and calming benefits that the rituals of kimonos, kabuki, Japanese calligraphy, traditional art & craft and tea ceremonies can provide. Rinko is also a curator for the development of new kimonos and Japanese accessories to appeal to a contemporary audience. She lives in Tokyo, Japan.

Kimonos

着物

Rinko Kimino

amber
BOOKS

Copyright © 2025 Amber Books Ltd

Amber Books Ltd
United House
North Road
London N7 9DP
United Kingdom

www.amberbooks.co.uk
Facebook: amberbooks
YouTube: amberbooksltd
Instagram: amberbooksltd
X(Twitter): @amberbooks

All rights reserved. No part of this work may be reproduced, stored in a retrieval system, or transmitted in any form or by any means, electronic, mechanical, photocopying, recording, or otherwise, without the prior permission of the copyright holder.

ISBN: 978-1-83886-612-9

Editor: Anna Brownbridge
Designers: Rajdip Sanghera & Mark Batley
Picture research: Terry Forshaw

Printed in China

Contents

Introduction		6
Chapter 1:	Structure and Styles of Kimonos	12
Chapter 2:	Motifs and Patterns	72
Chapter 3:	Classical Japan – Yamato period to Nara period (300–794 CE)	108
Chapter 4:	Modern Japan – Meiji period to Reiwa period (1868–present)	148
Chapter 5:	Kimonos for Life Milestones – from Birth to Death	196
Appendix: Periods of Japanese History		221
Glossary		222
Picture Credits		224

'Beauty of Kanbun Era' from the Edo period. The outer kimono is decorated by tie-dyeing with floral patterns.

はじめに
Introduction

THE KIMONO IS THE NATIONAL DRESS of Japan. For Japanese people, the kimono is far more than mere clothing – it is a mirror reflecting Japanese culture and history, a crystallization of aesthetic sensibilities and techniques cultivated over many years. Each kimono contains within it the delicate art of dyeing, the meticulous work of weavers and countless design elements passed down through generations. A single kimono weaves together Japanese artistic taste and seasonal awareness.

A kimono comes to life through a process of spinning threads, weaving fabric, dyeing and sewing. Each step of this process embodies the superior craftsmanship and innovative spirit of artisans. The first chapter introduces the fundamental structure of the kimono, the various types of kimonos and *obi* and the range of traditional techniques in dyeing and weaving. While

Introduction

はじめに the kimono is often discussed solely within the framework of 'Japanese traditional culture' in modern society, we also want readers to understand that the kimono is highly functional and represents sustainable fashion.

You might look at a kimono, with its multiple layers and various sashes and cords, and think it must be very constraining. However, in my experience, wearing a kimono is actually quite comfortable – the fabric wraps around your body in a way that feels truly embracing.

One of the kimono's most captivating aspects lies in the richness of its patterns. Whether depicting seasonal flowers, traditional motifs or auspicious designs, each pattern carries deep meaning. Chapter 2 explains the significance and origins of these patterns. Through these designs, one can understand how Japanese people cherish nature, constantly learning from and revering it.

Kyo-Yuzen is a traditional, hand-painted dyeing technique passed down in Kyoto.

Introduction

はじめに

A luxurious traditional kimono featuring vibrant floral designs with gold and silver embroidery, a garment such as this would be formal attire for unmarried women.

Introduction

はじめに

The history of the kimono is, in essence, the history of Japan itself. Chapters 3 and 4 trace the evolution of the kimono from the Yamato period (c. 300–710 CE) to the present day. We explore the role and significance of kimono in different eras, from the *juni-hitoe* (12 layers) that embodied the beauty of court culture, to the *kamishimo* (formal attire) for samurai and *kosode* that developed in samurai society, to the aesthetic sensibilities of common people that matured under Edo-period (1603–1867) regulations. We also examine how the kimono evolved after

'Dressing obi', photograph by Kusakabe Kimbei (1841–1934).

Introduction

Japan's long period of isolation ended and encountered Western culture and consider the place of the kimono in contemporary society.

The kimono has always been present during life's milestone moments. From birth, celebrating children growing up, coming of age and marriage, to the end of life – the appropriate kimono has been chosen for all significant occasions in Japanese life. Even in modern times, this attitude of cherishing life's pivotal moments remains unchanged. Chapter 5 explains the types and characteristics of kimono worn in these significant moments in our lives.

The kimono is by no means a relic of the past. It is a form of dress that holds rich potential for expressing the aesthetics and values of those living in the present day.

People often describe kimonos as magnificent works of art. While the technical mastery and beauty of a kimono's dyeing and weaving techniques are undoubtedly remarkable, I hope you appreciate more than just its visual beauty. Through the kimono, I want you to experience core Japanese values: treating objects with care, using things with genuine appreciation, passing traditions on to the next generation and being mindful not only of oneself but of others. These are the values that Japanese people hold in esteem.

Through this book, I hope readers will discover new aspects of the kimono's appeal, develop a deeper understanding of the kimono and above all experience Japanese culture through this iconic garment. Nothing would bring us greater joy. I would like this book to serve as a bridge in sharing the kimono culture inherited from our ancestors with the world.

Rinko Kimino

The fabric used to make kimonos, called bolts of cloth, is sold wound around a core rod.

CHAPTER 1

着物とテキスタイルの構造

Structure and Styles of Kimonos

Kimono Basics

Kimono shape

You've probably seen people wearing kimonos. But do you know what size a kimono is, what shape the fabric is made from and what the finished product looks like?

The traditional Japanese fabric used to make kimonos is called *tanmono*. It is a long, narrow bolt of fabric, typically measuring about 36–40cm (14–16in) in width and approximately 12–15m (40–50ft) in length. This size is specifically designed to provide just enough material to create one standard-sized kimono or other traditional garment.

For short *haori* jacket and long-sleeved *furisode*, bolts of fabric are

Structure and Styles of Kimonos

made with the length of fabric needed. Basically, one bolt is used to make a kimono. Even for smaller people, the excess fabric is tucked in rather than cut shorter.

Unlike ready-to-wear clothing, kimonos are usually tailored to fit the wearer, so the fabric from a *tanmono* is cut and sewn according to individual measurements. The design and patterns on the fabric are carefully aligned and adjusted during the tailoring process to ensure symmetry and balance when worn.

Kimono Fabric 14.5in x 40ft or 36.8cm x 12m

Sleeves | Front panel | Back panel | Okumi panels | Collars

A fabric panel for a kimono

Structure and Styles of Kimonos

For a kimono, the roll of fabric is cut into eight parts: the front and back body, two collar sections, two sleeves and two *okumi* sections (narrow panels that add width). In most cases, the fabric is cut in a straight line along the fibres, so no parts are discarded. Therefore, if the kimono is unstitched and resewn, it can be restored to the original roll of fabric before it is stitched. Formal kimonos, such as *furisode*, *tomesode* and *houmongi*, have a flowing pattern that runs from the front to the side and back.

This type of patterning on kimonos is called *eba-moyo*, and the white fabric is first made into a temporary shape for the kimono. After the temporary shape is made, a design is drawn and the pattern is applied using various techniques, such as *yūzen* dyeing and *shibori* tie-

Constructed kimono with sections as shown on the fabric panel.

Structure and Styles of Kimonos

dyeing according to the design. Once the design is drawn, the fabric is unravelled and returned to a single bolt of fabric. Fabric has been valuable to ordinary people since ancient times and has been used with great care.

Since antiquity, it has been the role of women to sew and manage the family's clothes throughout the year. Surprisingly, until the early Shōwa period (1926–1989), having a kimono tailored was an important condition for marriage.

As children grow, if the kimono becomes too small, it is unstitched and resewn to fit them perfectly. Before winter comes, kimonos are unstitched, washed, stuffed with cotton and resewn. Before sewing, any tears are repaired and small items are made into children's kimonos, nightwear, aprons, cushions, futons and dishcloths. Finally, the fabric is made into rags and dusters so that all the material is used up. The wisdom of managing precious fabric without waste is truly eco-friendly. This is one of the wonderfully functional and beautiful things about the kimono.

The great thing about kimonos, which can be unstitched and resewn back together, is that the entire fabric can be re-dyed. Any frayed, stained or discolored areas can be hidden in an invisible place when resewn, revealing only the beautiful parts. There are seam allowances so that the size can be adjusted as the child grows, and if the fabric becomes dirty or torn and there is no longer enough to make a kimono, it can be resewn into a *haori* jacket or *obi* sash.

STRUCTURE AND STYLES OF KIMONOS

着物とテキスタイルの構造

Women in the Edo period sewing kimonos, printed by ukiyo-e *artist Katsushika Hokusai.*

Structure and Styles of Kimonos

Types of Kimono

Kurotomesode (Black Formal Kimono)

Kurotomesode is a formal kimono typically worn by married women on formal occasions, such as weddings. It is characterized by a black background with intricate, colourful designs along the hemline. Often featuring five family crests (*kamon*) on the chest and back, this kimono is the most formal type for married women.

STRUCTURE AND STYLES OF KIMONOS

着物とテキスタイルの構造

This kurotomesode *has a fine black silk hem with a pattern of illustrated books and folding fans.*

STRUCTURE AND STYLES OF KIMONOS

Irotomesode (**Coloured Formal Kimono**)

Irotomesode is similar to *kurotomesode* but has a coloured background instead of black. It is a formal kimono often worn by relatives at weddings or formal ceremonies. *Irotomesode* also usually has family crests and designs around the hem.

Tsukesage

Tsukesage is a casual kimono. It has smaller, simpler patterns that are arranged in a specific, subtle order, making it appropriate for less formal occasions like tea ceremonies or gatherings.

Furisode

Furisode is the most formal kimono for unmarried women, characterized by its long, flowing sleeves. Often worn at Coming of Age ceremonies, weddings and formal events, *furisode* features vibrant, eye-catching designs and patterns.

Komon

Komon is a casual kimono with a repeating pattern across the fabric. Unlike formal kimonos, it has no distinct scene or specific motif placement, making it suitable for daily wear or casual outings. It can be dressed up slightly with accessories for more formal events.

Tsumugi

Tsumugi is a casual, handwoven kimono made from raw silk, often showcasing simple patterns or subtle colours. Known for its durability, it is suitable for everyday wear and casual events. *Tsumugi* kimonos are prized for their craftsmanship and are more informal than other silk kimonos.

STRUCTURE AND STYLES OF KIMONOS

着物とテキスタイルの構造

Irotomesode *from the Taishō era; Mount Fuji stands out from the indigo blue hem.*

STRUCTURE AND STYLES OF KIMONOS

着物とテキスタイルの構造

Formal houmongi *with blurred patterns and flowers drawn across the seams.*

Houmongi

Houmongi is a semi-formal kimono worn by both married and unmarried women. It often has continuous patterns flowing from the shoulders down to the sleeves and hem, symbolizing the wearer's openness to visit and socialize. *Houmongi* can be worn to various celebrations and parties.

The irotomesode *(left) and* houmongi *(right) are formal attire for married women.*

STRUCTURE AND STYLES OF KIMONOS

着物とテキスタイルの構造

Fine red crepe silk tsukesage *decorated with chrysanthemums, c. 1920–40.*

Iromuji

An *iromuji* kimono is a single-coloured kimono with no patterns, often worn for semi-formal or formal occasions. Its simplicity makes it versatile, suitable for tea ceremonies, graduations, or other events where understated elegance is appreciated. It can be dressed up with a family crest (*kamon*) or paired with different *obi* styles to suit the occasion.

Types of *Obi*

There are six main types of *obi* sash: *Maru obi*, *Fukuro obi*, *Nagoya obi*, *Hanhaba obi*, *Kaku obi* and *Heko obi*.

A woman visiting Fushimi Inari Shrine wearing an iromuji *kimono.*

STRUCTURE AND STYLES OF KIMONOS

Kaku obi

Kaku obi is a stiff, woven *obi* for men. It is tightly woven and thick in texture.

• Width: approx. 10cm (4in) x Length: approx. 4m (13ft)

Fukuro obi

The *fukuro obi* is a simplified and lighter version of the *maru obi*. It gets its name because the fabric of the front and back is sewn together into

Furisode *kimono decorated with large, bold designs of peonies, chrysanthemums, and other flowers, dyed in Yūzen dye.*

STRUCTURE AND STYLES OF KIMONOS

Colourful floral komon *kimono with vibrant chrysanthemum pattern and bright green* obi *sash.*

a tubular shape (*fukuro* means 'bag' in Japanese). It is the primary modern, formal *obi*.

- Width: approx. 30cm (12in) x Length: approx. 4.3m (14ft)

Nagoya obi

The *Nagoya obi* was developed in the Taishō period (1912–26) and is currently one of the most common and casual *obi* styles.

- Width: approx. 30cm (12in) x Length: approx. 3.6m (11.8ft)

STRUCTURE AND STYLES OF KIMONOS

Hanhaba obi

The *hanhaba obi* is narrower and thinner than other *obi* types, with a consistent width throughout. It is paired with everyday wear or summer *yukata*.

• Width: approx. 15cm (6in) x Length: approx. 3.8m (12.4ft)

Maru obi

Maru obi, which is rarely seen these days, has been used since the mid-Edo period and was the most prestigious *obi* for formal wear at that time. Today, it is mainly used for bridal costume or *maiko* (a geisha in training) costume.

• Width: approx. 70cm (27in) x Length: approx. 4.3m (14ft)

Tsumugi – *white* Oshima tsumugi *with a very soft texture and a* Tsumugi Nagoya obi *sash*.

STRUCTURE AND STYLES OF KIMONOS

Heko obi

Originally a soft *obi* for men introduced during the Meiji period, *heko obis* are now also available for children and women. Compared to other *obi* types, it is less constrictive and is popular for casual wear.

Maru obi – formal obi *sash from 1920-1940 with traditional patterns and plant motifs.*

STRUCTURE AND STYLES OF KIMONOS

着物とテキスタイルの構造

Fukuro obi: *The obi is also called a canvas and is decorated with beautiful alpine scenery.*

Ivory-white silk Nagoya obi *with embroidered Japanese traditional drums and a flute.*

STRUCTURE AND STYLES OF KIMONOS

着物とテキスタイルの構造

A fukuro obi, made with an abundance of gold and silver thread, is worn for formal and semi-formal occasions.

著物とテキスタイルの構造

STRUCTURE AND STYLES OF KIMONOS
Kimono Dyeing and Weaving

Kimonos can be broadly categorized into two types based on their production methods: dyeing and weaving.

A dyed kimono, referred to as *atozome* (post-dyeing), is created by first weaving undyed silk into a plain white fabric. Designs are then hand-painted or stencilled onto this fabric. In contrast, a woven kimono, known as *sakizome* (pre-dyeing), is produced by dyeing the threads before they are woven, with patterns created through specific weaving techniques.

A blue Hanhaba obi *shown in place tied around a kimono.*

STRUCTURE AND STYLES OF KIMONOS

着物とテキスタイルの構造

The Hanhaba obi *is tied in the front and wrapped around to the back.*

STRUCTURE AND STYLES OF KIMONOS

着物とテキスタイルの構造

Hakata-woven kaku obi *is an* obi *sash for men.*

Structure and Styles of Kimonos

Dyed kimonos are generally considered to be more formal and prestigious than woven kimonos. Many formal kimonos – such as *furisode, tomesode, houmongi, iromuji* and *komon* – fall under the dyed category.

Woven kimonos are called *katamono* and are characterized by the firmness of the fabric itself and a hard feel. Dyed kimonos are called *yawarakamono* and are soft to the touch and comfortable to wear, as they conform to the body's shape.

CHISO

Founded in 1555 in Kyoto, Chiso is a legendary kimono maker known for exquisite Kyo-*Yūzen* dyeing. Their elegant, handcrafted designs are often worn for weddings, Coming of Age ceremonies and other special occasions, making Chiso a symbol of refined Japanese tradition and beauty. Their creations are considered as both wearable art and cultural heritage.

STRUCTURE AND STYLES OF KIMONOS

Dyed Kimono

Dyeing refers to the process of adding colour and patterns to a single piece of fabric, resulting in vivid and intricate designs. There are various dyeing techniques, with the main ones including *yūzen* dyeing, stencil dyeing, *katazome*, *komon*, *bingata*, *sarasa* and *shibori*.

Yūzen Dyeing

Yūzen dyeing is one of the most representative dyeing techniques. Using brushes or other tools, it combines hand-painting and *katazome* stencil techniques to create detailed, vibrant patterns. It is particularly characterized by drawing the outlines called *itome* with a dye-resistant paste, which prevents the colours from bleeding and results in vivid patterns. The three major types of *Yūzen* are Kyo *Yūzen* from Kyoto, Kaga *Yūzen* from Kanazawa and Tokyo *Yūzen*.

Kyo *Yūzen*

There are several theories, but it is generally believed that *Kyo Yūzen* was established by Miyazaki *Yūzen*-sai, a fan painter in the Edo period. Kyo *Yūzen* is considered the foundation of all *Yūzen* styles. Often featuring multicoloured gradations that fade from the inside outward, it commonly uses classical motifs such as flowers, birds and seasonal themes. Known for its vibrant classical patterns and embellishments with embroidery and gold leaf, it has become one of Japan's representative kimono styles. Today, many Kyo *Yūzen* pieces are still dyed in Kyoto.

STRUCTURE AND STYLES OF KIMONOS

着物とテキスタイルの構造

Skilled weaver creating traditional Nishijin *textile on wooden loom in Kyoto workshop.*

STRUCTURE AND STYLES OF KIMONOS

Kaga *Yūzen*

Kaga *Yūzen* is also said to have originated with Miyazaki *Yūzen*-sai, who worked as a fan painter in Kyoto before promoting dyeing techniques in Ishikawa Prefecture. Kaga *Yūzen* is characterized by its use of the 'Kaga Goshiki' (Five Colours of Kaga) palette: indigo, ochre, crimson, green and ancient purple. Unlike Kyo *Yūzen*, it seldom incorporates gold leaf or embroidery, relying solely on the *Yūzen* dyeing technique. Its unique features include 'outside blurring', where darker colours fade to lighter ones from the outer edges inward, and the use of small ink-coloured dots, called *mushikui* (insect-eaten) design, often seen on leaf motifs.

Black mesh woven silk, summer kimono decorated with pheasants and autumn flowers.

STRUCTURE AND STYLES OF KIMONOS

着物とテキスタイルの構造

*Artisan hand-paints intricate kimono design
using traditional Kyoto Yūzen dyeing technique.*

39

STRUCTURE AND STYLES OF KIMONOS

*A silk kimono with an orchid motif dyed using
the Kyo-Yūzen dyeing technique.*

Tokyo *Yūzen*

Tokyo *Yūzen* is said to have been brought from Kyoto to Tokyo during the Edo period. It is distinguished by a limited colour palette, often favouring subdued hues like brown, indigo and white. Compared to Kyo and Kaga *Yūzen*, it has a notably different feeling, favoring sleek and simple designs.

STRUCTURE AND STYLES OF KIMONOS

Katazome (Stencil Dyeing)

Katazome is a traditional dyeing technique believed to have originated in the Nara period (710–794 CE). By the Kamakura period (c. 1192–1333), stencil dyeing using paper stencils had begun, and it quickly spread from samurai clothing to common townspeople during the Edo period.

In general, *katazome* involves carving patterns into three layers of thick, persimmon-coated Japanese paper (known as *Ise katagami*, itself a traditional craft). This stencil is placed over the fabric and a dye-resistant paste is applied. When the fabric is then dyed, the paste prevents colour

Artisan hand-paints intricate kimono design using traditional Kyoto Yūzen dyeing technique.

Structure and Styles of Kimonos

from adhering to the patterned areas, which remain white. As one stencil is needed per colour, patterns with many colours can require more than 100 stencils. The *katazome* process is carried out in stages by different craftsmen. Its features include the ability to repeat the same pattern multiple times and produce identical patterned fabrics.

Katazome (Picture Stencil Dyeing)

Unlike other *katazome* techniques, where each step is handled by different artisans, *katazome* involves a single artist creating the design, carving the stencil and dyeing the fabric, allowing for a more painterly and cohesive process.

> **GINZA MOTOJI**
>
> A luxury kimono boutique located in Ginza, Tokyo, Ginza Motoji offers carefully curated works from Japan's top weavers and dyers. Known for its refined collection and personal service, the shop also supports modern interpretations of the kimono, including men's kimono fashion and bespoke tailoring rooted in traditional craftsmanship.

STRUCTURE AND STYLES OF KIMONOS

着物とテキスタイルの構造

This unique summer kimono features stencil-dyed illustrations from Jippensha Ikku's novel Hizakurige *published in 1802.*

Structure and Styles of Kimonos

Edo Komon (**Edo fine patterns**)

Edo komon is a type of stencil dyeing with extremely fine patterns that appear solid from a distance. The smaller the pattern, the more advanced the technique required. Originating from patterns on the *kamishimo* (formal attire) of Edo-period samurai, *Edo komon* designs evolved as unique motifs, symbolizing different domains (fiefdoms).

Ryukyu *Bingata* (**Okinawan** *Bingata*)

Bingata originated around the 13th century in Okinawa, where it was traditionally used for the clothing of royalty and noble families. This style is known for its vivid colours, beautiful colour combinations and unique patterns created using stencils in a range of colours, from vibrant hues to indigo shades.

Edo *Sarasa* (**Edo Chintz**)

Edo *sarasa* was inspired by chintz patterns on cotton fabric that originated over 3000 years ago in India and spread to Europe and Asia. It is said to have reached Japan in the 14th–16th centuries, where traditional *katazome* techniques were applied to develop a unique Japanese style. Even small patterns require 30–40 stencils, while larger patterns may need up to 90 stencils, resulting in intricate gradations and shading effects. Today, this technique continues to be practised in Tokyo.

STRUCTURE AND STYLES OF KIMONOS

A brightly coloured bingata *kimono with a peony pattern.*

Edo Sarasa is a type of fabric with complex patterns printed in multiple colours.

着物とテキスタイルの構造

45

STRUCTURE AND STYLES OF KIMONOS

Shibori Dyeing

Shibori dyeing is a technique with a history of more than 1300 years. It involves tying, sewing, or clamping parts of the fabric to create undyed sections, forming wave-like or tiny dotted textures known as *shibo*. This meticulous work, done by hand, requires an immense amount of time. Famous traditional *shibori* techniques include Kyoto's *Kyokanoko shibori* and Nagoya's *Arimatsu Narumi shibori*.

Kanoko *Shibori*

Kanoko *shibori* is a type of tie-dyeing that was widely developed in the Edo period. Kyoto's *Kyokanoko Shibori*, created on high-quality silk, has a unique textured quality with *shibo* patterns, making it a symbol of luxury that was favoured by the Edo upper classes at the time. Today, it is still regarded as a hallmark of exquisite craftsmanship, with ten different methods passed down through the generations.

Arimatsu Narumi Shibori

Developed in the Arimatsu and Narumi regions of Nagoya during the Edo period, this technique uses cotton, and was popularized by ordinary people. Patterns are created by tying, sewing or pleating the fabric without the use of sketches and relying solely on skill. Although over 100 variations of *shibori* once existed; approximately 70 techniques are still in use today.

STRUCTURE AND STYLES OF KIMONOS

Each bead is dyed in indigo using a dyeing technique called **Kanoko shibori**.

Edo **komon** *is dyed with very small patterns that appear to be solid colours when seen from a distance.*

着物とテキスタイルの構造

STRUCTURE AND STYLES OF KIMONOS

着物とテキスタイルの構造

Burgundy kanoko shibori *bridal kimono depicting autumn maple leaves over flowing water pattern.*

STRUCTURE AND STYLES OF KIMONOS

着物とテキスタイルの構造

Elegant kanoko shibori *kimono depicting traditional cormorant fishing scenes with tie-dye technique.*

Structure and Styles of Kimonos

Aizome (Indigo Dyeing)

Aizome is a dyeing technique that uses the plant-based indigo dye, known as one of the oldest dyes in human history and found worldwide. It is believed to have been introduced to Japan during the Nara period. By the Heian period (794–1185 CE), it was regarded as a noble colour, and one of the treasures in the Shoso-in Temple, Nara, includes a piece of fabric dyed with indigo.

During the Edo period, *aizome* became widely used for everyday items, such as clothing, half-coats, curtains, wrapping cloths and hand towels. This distinctive blue colour is often referred to as 'Japan Blue'. The term was coined by the British scientist R. W. Atkinson who, upon arriving in Japan in the early Meiji period, described the commonly worn fabric in such terms.

Traditional Japanese indigo-dyed fabrics showing shibori *tie-dye patterns – floral motif and horizontal striped design.*

STRUCTURE AND STYLES OF KIMONOS

Woven Kimono

Woven kimonos, known as 'pre-dyed' garments, are robes made by dyeing threads before weaving them to create patterns through the weaving method. These are generally worn as casual kimono types, including *tsumugi*, *omeshi* and cotton kimono.

Tsumugi

Tsumugi is a woven textile created by spinning yarn from silkworm cocoons, twisting it to form strong threads and then weaving them. Since *tsumugi* patterns are made by weaving dyed threads, the finer the pattern, the more skilled the craftsmanship required. Various types of *tsumugi* exist throughout Japan, but the most typical are *Yuki tsumugi*, *Oshima tsumugi* and *Ushikubi tsumugi*.

Handwoven Yuki tsumugi *is unique silk, known for softness and intricate kasuri patterns.*

Yuki tsumugi *is silk using techniques that have been in use since the 8th century CE.*

着物とテキスタイルの構造

Structure and Styles of Kimonos

着物とテキスタイルの構造

Indigo dyeing is a traditional Japanese dyeing method that uses natural dyes extracted from indigo leaves.

STRUCTURE AND STYLES OF KIMONOS

着物とテキスタイルの構造

53

STRUCTURE AND STYLES OF KIMONOS

Yuki Tsumugi

A silk textile produced around Yuki City in Ibaraki Prefecture and Oyama City in Tochigi Prefecture, Yuki *tsumugi* has a history dating back to the Nara period. It is registered as an Important Intangible Cultural Property of Japan and in 2010 was inscribed on the UNESCO Representative List of the Intangible Cultural Heritage of Humanity The yarn is hand-spun from silk floss, giving it soft, lightweight and heat-insulating qualities.

Oshima Tsumugi

Known as one of the world's three greatest dyed textiles, alongside Gobelin tapestry (France) and Persian carpets (Iran), *Oshima tsumugi* is a silk textile created with the mud-dyeing technique of the Amami Islands in southern Kagoshima Prefecture. With over 30 complex and precise processes, it requires advanced skills. It is said to be durable enough to last 200 years.

White Oshima tsumugi *with a very soft texture and* tsumugi Nagoya obi *sash.*

STRUCTURE AND STYLES OF KIMONOS

着物とテキスタイルの構造

Oshima tsumugi *is a prestigious silk fabric from Amami islands featuring intricate mud-dyed* kasuri *patterns.*

STRUCTURE AND STYLES OF KIMONOS

Ushikubi Tsumugi

This silk textile is woven in the Shiramine area of Hakusan City, Ishikawa Prefecture. It is produced by spinning yarn from cocoon clusters made by two silkworms. Almost all stages of the production, from yarn-making to weaving, are done by hand. *Ushikubi tsumugi* is unique in being the only *tsumugi* made with white base fabric and dyed afterward. It is so durable that if it were to catch on a nail, the nail would be pulled out before the fabric would tear. This has earned it the nickname *Kuginuki tsumugi* (nail-resistant *tsumugi*).

Omeshi

Omeshi is renowned as a high-quality fabric with a pleasant feel and crisp texture. 'Nishijin *Omeshi*' from Kyoto is particularly famous. The 11th Tokugawa *Shōgun* Ienari (1773–1841) wore this fabric so much that it became highly prestigious among woven kimonos and was considered the most luxurious. Men's plain *omeshi*, if adorned with a family crest, can be worn for occasions such as tea ceremonies or semi-formal gatherings.

STRUCTURE AND STYLES OF KIMONOS

着物とテキスタイルの構造

Omeshi silk fabric, named after the 11th Tokugawa shogun Ienari, who favoured it during Edo period.

Structure and Styles of Kimonos

Momen (Cotton)

Today, cotton is one of the most familiar materials, but it only became widely accessible to ordinary people in Japan during the Edo period. Since then, various distinctive cotton textiles have emerged in different regions, including Kurume *Kasuri*, Ise *Momen*, Katagai *Momen*, Tateyama Tozan and many more.

Kurume Kasuri

Kasuri is a technique unique to pre-dyed kimono. Around 1800, Kurume *Kasuri* was developed by Inoue Den, who created patterns by tying threads, dyeing them in indigo and weaving them. It involves more than 30 advanced techniques, including design creation, tying of warp and weft threads, dyeing and weaving. This cotton textile is known for its rustic feel, intricate *kasuri* patterns and beautiful indigo colour.

Kurume Kasuri *is a traditional Japanese cotton fabric with distinctive* ikat-*style patterns.*

STRUCTURE AND STYLES OF KIMONOS

着物とテキスタイルの構造

Karume Kasuri

Structure and Styles of Kimonos

A dyeing area lined with indigo vats for dyeing Kurume Kasuri *thread.*

STRUCTURE AND STYLES OF KIMONOS

Structure and Styles of Kimonos

Ise *Momen*

Ise *momen* from Mie Prefecture is known for its soft texture and durability. Since the Edo period, it has been an essential fabric for the common people. However, today, only one weaving shop continues to produce Ise *momen*.

Weaves and Dyes of *Obi* Belts

Similar to kimonos, *obi* belts are classified into woven and dyed types. Unlike kimonos, woven *obis* are considered superior to dyed ones. Among the various weaving techniques and materials, the three major regions for woven *obi* belts in Japan are Nishijin in Kyoto, Hakata in Fukuoka Prefecture and Kiryu in Gunma Prefecture.

An artisan producing coloured dyes for use on kimonos.

STRUCTURE AND STYLES OF KIMONOS

着物とテキスタイルの構造

*A woodblock print depicting the town of Arimatsu,
where colourful Arimatsu-shibori cloth is drying.*

Structure and Styles of Kimonos

Woven *Obi*

Nishijin *Ori* (Weaving)

Obi belts woven in the Nishijin area of Kyoto are called Nishijin *Ori*. These belts range from luxurious *fukuro obi*, made with gold and silver threads, to *nagoya obi*. Nishijin is the region in Japan known for its highest production volume, with most *obi* belts in circulation believed to be made there. The production process involves a sequence of intricate steps, with specialized artisans working collaboratively in a division of labour.

Kiryu *Ori* (Weaving)

Known as 'Nishijin of the West, Kiryu of the East', Kiryu *ori* boasts a history of more than 1000 years, with origins going back to the Nara period. During the Edo period, Kiryu became known for producing luxurious textiles, such as *kinran* and *doncha*. Even today, the seven traditional techniques of Kiryu weaving have been preserved, creating patterns and colours with a deep expression and beauty.

Hakata *Ori* (Weaving)

'Hakata *Ori*' gained its reputation when Kuroda Nagamasa (1568–1623), the feudal lord of Fukuoka Domain, presented it to the Tokugawa shogunate during the Edo period. This led to its alternate name, 'Hakata Kenjo'. Its iconic pattern features *dokko*, a Buddhist ritual tool. Renowned for its sturdy fabric and strong grip, it was traditionally used by samurai to secure their heavy swords at the waist.

STRUCTURE AND STYLES OF KIMONOS

着物とテキスタイルの構造

Hakata-ori hanhaba obi *woven with many warp threads and thick weft threads firmly beaten in.*

STRUCTURE AND STYLES OF KIMONOS

着物とテキスタイルの構造

Nishijin textile features woven phoenixes, clouds and flowers in intricate, traditional Japanese designs.

STRUCTURE AND STYLES OF KIMONOS

着物とテキスタイルの構造

*Nishijin-*ori *is a traditional Kyoto textile known
for its rich, elaborate silk weaving.*

Structure and Styles of Kimonos

Dyed *Obi*

Dyed *obi* belts feature patterns drawn and dyed on a white base fabric. Techniques include hand-painted dyeing, *Katazome* stencil dyeing, *bingata*, *shibori* and *sarasa*. The materials range from silk and pongee to cotton and hemp. Dyed *obi* belts are noted for their seasonal motifs and intricate, delicate details.

Kimono homongi from Showa era with dyed silk, worn with a fukuro obi from Showa era.

STRUCTURE AND STYLES OF KIMONOS

着物とテキスタイルの構造

Woodcut from c. 1820 featuring a courtesan in long red silk under-kimono decorated with white tie-dyed starfish pattern.

69

Structure and Styles of Kimonos

着物とテキスタイルの構造

Hakata-ori is a traditional Fukuoka textile known for its thick, durable silk patterns.

STRUCTURE AND STYLES OF KIMONOS

着物とテキスタイルの構造

モチーフとパターン

*A vibrant red kimono adorned with golden cherry tree branches
and soft white blossoms from the late Edo period.*

CHAPTER 2

モチーフとパターン

Motifs and Patterns

IN JAPAN, TRADITIONAL PATTERNS HAVE long been applied to various items, such as kimonos, lacquerware, ceramics and architecture. Among these, the most numerous are designs inspired by nature, especially plants and flowers.

When it comes to floral kimono and *obi* designs, we are particularly mindful of the season in which they are worn.

Realistic floral patterns are chosen based on their seasonal appropriateness, while abstract or stylized designs can generally be worn all year round.

Realistic floral designs are seen as a tribute to the beauty of real flowers, which is why we avoid wearing them during the peak blooming period.

MOTIFS AND PATTERNS

Seasonal Kimono Patterns

Instead, it is considered elegant (*iki*) to wear them a little before they are in full bloom, as if to say, 'The flowers will bloom soon.'

Some flowers without leaves or branches, such as sakura and chrysanthemum, are emblematic of Japan and can be worn throughout the year.

For example, a realistic camellia design depicting the flower with leaves and branches is worn just before it reaches full bloom. On the other hand, a stylized or abstract camellia design can be worn all year round.

Seasonal motifs are often incorporated at transitional times: for example, by wearing autumnal designs at the end of summer. Coordinating kimono with colours that evoke the seasons is also a common practice.

The peony motif originated in China and began appearing in Japanese decorative arts in combination with long-tailed birds.

MOTIFS AND PATTERNS

モチーフとパターン

This elegant kimono features vibrant peonies and pheasants in a serene natural palette.

Motifs and patterns

モチーフとパターン

*On this kimono, there is a pattern of iris flowers blooming
and plank bridges joined together over stream.*

Some kimono or *obi* belts feature designs of flowers representing all four seasons. This is both a way to celebrate the changing seasons and to ensure the garment can be worn over a longer period.

Here is a list of the floral patterns we traditionally wear during each month of the year:

MOTIFS AND PATTERNS

The motif of hydrangea blossoms and butterflies for the rainy season.

Spring (March–May)

March: Cherry blossom, magnolia, rape blossom

April: Peony, wisteria, willow

May: Iris, green maple leaves, rain

Summer (June–August)

June: Iron wire, hydrangea, lily

July: Morning glory, Chinese lantern, goldfish

August: Pinks, Chinese bellflower, running water

MOTIFS AND PATTERNS

モチーフとパターン

Morning glories tangle and bloom as a tiny tree frog hides among the leaves.

Summer patterns are dyed on lightweight fabrics.

MOTIFS AND PATTERNS

Autumn (September–November)

September: Chrysanthemum, moon, insect cage

October: Ginkgo, pomegranate, autumn leaves

November: Drifting flowers, camellia, nuts

モチーフとパターン

A summer kimono with designs of Chinese bellflowers, plovers and streams.

MOTIFS AND PATTERNS

モチーフとパターン

*Elegant chrysanthemums bloom in autumn hues
against a deep twilight blue background on this garment.*

MOTIFS AND PATTERNS

モチーフとパターン

Autumn leaves, which evoke the feeling of autumn, are often depicted on kimonos and obi.

The deformed camellia pattern is not limited to any one season.

Motifs and patterns

モチーフとパターン

Winter (December–February)

December: Christmas, snow circles, pine needles

January: Daffodil, pine, bamboo, plum, New Year's pattern

February: Camellia, bamboo, Japanese bush warbler

Snowflake patterns were popular during the Edo period.

MOTIFS AND PATTERNS

モチーフとパターン

A child's kimono with pine, bamboo, plum blossoms and fans.

MOTIFS AND PATTERNS

モチーフとパターン

Women's kimono with origami cranes and stylized green camellias.

MOTIFS AND PATTERNS

Traditional and auspicious Japanese patterns

In addition to patterns stylized from plants, there are also designs featuring creatures such as birds, fish, shellfish and insects, as well as patterns inspired by nature, including the moon, stars, lightning, mountains, rivers and waves. Among these, there are also unique *yakusha monyo* (actor patterns) created by kabuki actors during the Edo period as their personal trademarks.

One of the most frequently seen types of traditional patterns are *kissho monyo* (auspicious patterns), which symbolize good fortune. Each design carries specific wishes or meanings, such as prosperity for descendants or protection from disasters and misfortunes. Here, we will introduce some of these patterns along with their meanings.

CHIKUSEN

Established in the Edo period, Chikusen is famous for its high-quality *yukata* and *Edo-komon*. Their traditional dyeing methods, such as *chusen* and *katazome*, reflect the *iki* spirit of Edo culture. Loved for its timeless patterns and elegant simplicity, Chikusen continues to make traditional summer kimonos relevant in the contemporary era.

モチーフとパターン

Motifs and patterns

Geometric Patterns

Kikkō (**Tortoise Shell**)

A geometric pattern consisting of connected hexagons resembling a tortoise shell.

Tortoises are a symbols of longevity, and this pattern is considered a good luck motif, signifying the desire for health and fortune.

Uroko (**Scales**)

A pattern of triangles arranged horizontally and diagonally, inspired by the scales of fish or snakes.

Uroko is believed to offer protection against evil and is said to represent regeneration.

Even today, some women wear undergarments with a Uroko *pattern to ward off evil spirits.*

MOTIFS AND PATTERNS

モチーフとパターン

The background pattern features Kikkō *(left) and* w *(right),
each of which represents a wish.*

It is customary to wear *uroko* as a pattern on women's *nagajuban* (undergarments) to ward off evil.

Seigaiha (**Blue Ocean Waves**)

A design of overlapping semicircles reminiscent of waves.

This pattern represents an endless expanse of calm waves and expresses a longing for a life of peace and serenity to last forever.

Shippō (**Seven Treasures**)

A geometric design made by connecting four equally sized circles.

MOTIFS AND PATTERNS

モチーフとパターン

*A garment with a Shippō pattern featured
in a kimono design catalogue from the 1800s.*

MOTIFS AND PATTERNS

The overlapping circles symbolize infinite harmony, prosperity and the spreading of good fortune. The name comes from the Buddhist 'Seven Treasures'.

Asanoha (**Hemp Leaves**)

A pattern based on the shape of hemp leaves, structured with regular hexagons.

Hemp, a sacred plant used in rituals, grows straight and tall within a few months, symbolizing vitality and growth. Because it grows straight up to a height of several metres in just a few months, it was customary to dress babies in hemp leaf-patterned baby clothes as a talisman and to ensure the healthy growth of the child.

モチーフとパターン

The costumes of kabuki actors in the Edo period featured asanoha, *hemp leaf patterns.*

Motifs and patterns

モチーフとパターン

The costumes combine embroidery and gold leaf to create Ichimatsu *patterns, irises and fans.*

Kagome pattern is designed using hexagonal weaving, a typical technique from the Edo period.

Ichimatsu (**Checkered pattern**)

A checkered pattern of alternating squares in two colours.

As it continues endlessly up, down, left and right, it is imbued with the meaning of prosperity and development. In the Edo period, it became popular when the kabuki actor Sanogawa Ichimatsu popularized it by wearing it in his costumes.

Kagome (**Basket Weave**)

A pattern inspired by the woven mesh of bamboo baskets, resembling a series of interlocked hexagrams. This design is believed to ward off evil spirits and protect against misfortune due to its association with hexagrams, which are thought to repel demons.

Motifs and patterns

Auspicious Patterns

Matsu-take-ume (Pine, Bamboo and Plum)

Since ancient times, pine and bamboo, which remain green even in winter, and plum blossom, which blooms in the cold of February, have symbolized endurance, longevity and hope. These motifs are treasured as auspicious patterns and often feature on kimonos and *obi* for New Year's celebrations and weddings.

Takara-zukushi (Treasure Motif)

This pattern combines various treasures, such as the magic mallet, invisibility cloak, invisibility hat and golden pouch, inspired by Buddhist scriptures. It expresses wishes for happiness and prosperity and is used at festive occasions and New Year's celebrations.

Takara-zukushi *(left), the* ogi *pattern (right), which is a sign of good fortune.*

MOTIFS AND PATTERNS

モチーフとパターン

Furisode *kimono decorated with the winter motif of pine, bamboo and plum.*

MOTIFS AND PATTERNS

モチーフとパターン

*The costume worn by Ichikawa Danjuro VII
in the play has a gourd pattern.*

Ōgi (Fan)

The folding fan, which originated to deal with Japan's hot and humid climate, is considered a symbol of good fortune. When the fan is opened, it spreads out at the end, so it is regarded as an auspicious sign of a bright future, prosperity and good luck.

Hyōtan (Gourd)

Gourds have long been seen as vessels for divine spirits and are used in rituals. They are considered talismans for protection against disasters. Additionally, their clustered growth symbolizes prosperity and the flourishing of descendants. Three gourds together signify good fortune (a play on words, *sanpo yoshi*), while six represent good health (wordplay on *mubyō*, or 'six gourds'), making them popular auspicious motifs.

Kai-zukushi (Seashells Motif)

Kai-zukushi is a design made by gathering seashells of various shapes. Shells symbolize life and abundance, while clams, which can only be perfectly matched with their own halves, represent marital harmony and family unity.

Tatewaku (Rising Steam)

A wavy pattern depicting steam rising from the ground. It symbolizes aspirations for success and upward movement. There are several variations combined with motifs such as waves, foxglove trees, clouds and flowers.

MOTIFS AND PATTERNS

モチーフとパターン

This uchikake *is decorated with a flowing design of wisteria flowers in Tatewaku pattern.*

Nanten (Sacred Bamboo)

The *nandina* tree is associated with the phrase, 'Problems are turned into good fortune', making it a talisman for protection and against calamities. Its leaves are often mixed with red bean rice for their detoxifying properties, and its red berries are used as cough medicine. The *Nandina* is an essential part of New Year's decorations.

Karakusa (Arabesque)

A pattern of intertwined vines, representing the strong vitality of creeping plants. Vines have strength, and the way they grow in all directions symbolizes hopes for the prosperity and long life of future generations.

MOTIFS AND PATTERNS

モチーフとパターン

Noh *costume depicting a book and a* nandina *flower bearing bright red berries.*

MOTIFS AND PATTERNS
Animal Motifs

Oshidori (**Mandarin Ducks**)

In Japan, a happily married couple is called *oshidori-fuufu*. *Oshidori*, with their beautiful coloured feathers, have been cherished since antiquity as a symbol of marital happiness because of the harmonious appearance of a male and female swimming together. As an auspicious motif, it is often depicted on formal kimonos and *obi*, such as wedding costumes and *furisode*.

This is an indigo dye seamless block print pattern, a traditional motif with chrysanthemum flowers and arabesques.

MOTIFS AND PATTERNS

モチーフとパターン

A Maru obi with a design of mandarin ducks, pine, bamboo, plum and streams.

Fukura-suzume (Plump Sparrow)

This motif depicts sparrows puffing up their feathers to keep warm in winter. Their plump and well-fed appearance signifies their desire for lives filled with abundance. The motif is written using auspicious characters, which mean 'good fortune is coming'.

MOTIFS AND PATTERNS

モチーフとパターン

Tonbō (**Dragonfly**)

Dragonflies only fly forwards and never retreat, earning them the nickname *kachi-mushi* ('victory insects'). They were often used in samurai armour designs to symbolize victory. The dragonfly's tendency to land on top of things also represents hopes for success in life. The design has been used as a pattern on clothing for baby boys.

The dragonfly-patterned obi *is worn from summer to autumn, so the material is lightweight.*

MOTIFS AND PATTERNS

Tsuru-kame (Crane and Tortoise)

The combination of cranes and tortoises in a motif reflects the saying, 'The crane lives a thousand years, the tortoise ten thousand.' Together, the two creatures symbolize longevity, health and happiness, making them a classic propitious emblem.

モチーフとパターン

The dragonfly pattern became popular and was used by samurai.

MOTIFS AND PATTERNS

モチーフとパターン

A kimono for weddings decorated with cranes and turtles, which are symbols of longevity.

MOTIFS AND PATTERNS

モチーフとパターン

Beautiful ladies shown wearing the fashionable kimonos of the Edo period. The obi *with snowflake pattern.*

Natural Patterns

Yukiwa (Snow Wheel)

In years with heavy snowfall, the abundant meltwater in spring often leads to a bountiful harvest in autumn. Snow has been called the 'spirit of the five grains' since ancient times, leading to a good harvest. The *yukiwa* pattern, inspired by snowflakes and designed in a circular shape, is not only a winter motif but is also used in summer garments like *yukata* that are lighter and cooler.

MOTIFS AND PATTERNS

Kumodori (Cloud Pattern)

The *kumodori* pattern features various motifs arranged within the outlines of clouds. Traditionally, cloud patterns are often used in Buddhist art and decorations. Since antiquity, it has been believed that mysterious gods and spirits reside in clouds and control the weather.

This kumodori *pattern features various traditional motifs drawn within cloud-shaped lines.*

Kanze-mizu (**Kanze Water**)

A pattern depicting flowing water with curved lines. Water has long been used for purification, and the saying 'flowing water does not stagnate' symbolizes the wish for enduring purity and health in one's life. The name originates from the Kanze family of Noh theatre performers, who adopted this design as its formal pattern.

An obi *sash with slightly deformed swans and a* kanze mizu *motif.*

MOTIFS AND PATTERNS

モチーフとパターン

A Noh costume with kanze-mizu, *water plants and leaves from the 19th century.*

Yukimochi (Snow-laden Branches)

The *yukimochi* pattern depicts snow falling and piling up on plants, such as willow, bamboo, pine, camellia and *nandina*. The branches bend gracefully beneath the snow's weight then stand up again as it falls away – a testament to the strength and hope that endures in anticipation of spring.

MOTIFS AND PATTERNS

モチーフとパターン

A woman wearing a snow-covered bamboo-patterned kimono chooses an obi.

古典着物時代（大和〜江戸時代）

A courtesan wearing a kimono with a plum blossom motif from Edo period.

CHAPTER 3

古典着物時代
(大和〜江戸時代)

Classical Japan
Yamato period to Nara period
(300–794 CE)

THE LATTER HALF of the 3rd century saw powerful clans expand their influence, with the Yamato court unifying the country and increasing exchanges with the Chinese mainland. Weaving techniques were also introduced from the mainland and the Korean Peninsula.

Men wore relatively simple clothing, such as *kanto-i* – a piece of cloth wrapped around the body with a hole for the head, thought to be the earliest form of clothing – and trousers, while women wore long skirts. Wearing comma-shaped, often jade jewellery (*magatama*) and gilt bronze decorative items showed status and authority. It is thought that this type of clothing was spread from the nomadic horse-riding people of ancient China (Hu) via China and the Korean Peninsula. From archaeological clay figurines (*haniwa*), we know

CLASSICAL JAPAN

古典着物時代（大和〜江戸時代）

that both men's and women's garments wrapped left-over-right, which is the opposite to today's style.

In the 5th century CE, Buddhism was introduced from China, and various cultural elements were also imported from the mainland. The clothing cultures of the Sui and Tang dynasties in China and the Baekje and Silla kingdoms on the Korean Peninsula were adopted. Advanced dyeing techniques were introduced, and vibrant clothing was made using indigo and madder dyes, with particularly sumptuous attire worn for religious events and ceremonies.

In the 7th century CE, Japan's first fully developed urban culture flourished with the founding of the capital at Heijō-kyō. In the history of Japanese fashion, the Nara period was influenced by the Tang style, in which social class (upper and lower) dictated the clothes a person wore and clothing regulations based on the Ritsuryo system were introduced.

The ranks of government officials were classified by the colour and shape of their crowns and clothing. This was known as the Twelve Cap Rank System (*kanui junikai*). Each of the 12 ranks was assigned a cap with shades running down from purple, blue, red, yellow and white to black and grey for the lowest. This cap and rank system prohibited people from wearing colours, crowns and clothing above their own rank.

In addition, the *Sankofuku* system was established to classify clothing into three categories based on social status: formal wear, morning wear and uniforms. The rank system began to be reflected in the clothing of government officials.

The ruling class's attire (morning wear) seems to have been a coat-like

CLASSICAL JAPAN

古典着物時代（大和〜江戸時代）

*Prince Shotoku began creating a new nation
from around the end of the 6th century CE.*

garment with a stand-up collar and *hakama* (trousers) for men and a pleated long skirt and wide-sleeved kimono for women. Women also wore an apron-like, pleated garment layered over the top.

During the Nara period, clothing overlap changed from the earlier left-over-right style to the current right-over-left style. The ruling class wore

Classical Japan

clothes made of high-quality silk fabrics, while common people wore simple hemp clothing.

Heian period to Azuchi-Momoyama period (794–1600 CE)

Unlike the Nara period, which was influenced by China, the Heian period saw the end of the official missions to Tang China in 894 CE, and cultural exchange with the continent came to an end. Gradually, Japan began to develop its own unique culture. Fashion also fused Chinese and Japanese styles and clothes suited to the Japanese climate and lifestyle began to be made. Furthermore,

Tang China - Standing court lady, 7th-8th century.

CLASSICAL JAPAN

古典着物時代（大和〜江戸時代）

Takamatsuzuka murals from the Yamato era.

113

CLASSICAL JAPAN

古典着物時代（大和〜江戸時代）

Empress Komyo from the Nara era.

Classical Japan

the development of dyeing and weaving techniques gave rise to a more diverse range of clothing.

From the end of the Nara period and through the Heian period, a distinction in clothing worn by aristocrats (*kuge*) and commoners based on their status became firmly established. Nobles began to wear luxurious garments that covered their arms and legs, while commoners wore simple, practical garments with tube-shaped sleeves that were easy to move in. People began to make kimonos by cutting fabric in straight lines and sewing them together, and wide cuffs, loose-fitting bodices and *hakama* were designed to suit Japan's climate and geography.

古典着物時代（大和〜江戸時代）

OKAJU

A Kyoto-based house with roots in the Yūzen dyeing tradition, *Okaju* is renowned for its unique and artistic kimono designs. Their creations blend boldly coloured antique motifs with contemporary flair. *Okaju* also offer modern accessories that appeal to a new generation of kimono enthusiasts and collectors.

古典着物時代（大和〜江戸時代）

The kimono could be layered in cold weather, and cool materials such as linen were used in hot summers. The practice of layering kimonos of the same style became established, and a sense for combining colours developed. Japan's unique tradition of colour harmony emerged, in which colour combinations signified social class and specific hues symbolized the changing seasons.

Typical clothing of this era includes the *sokutai* (traditional court outfit) worn by male aristocrats and the *jūni-hitoe* worn by female aristocrats. *Sokutai* was the second most formal attire after formal wear. It was worn by everyone from the emperor to his courtiers for ceremonies and official occasions. Women's *jūni-hitoe* is a later name for layered clothing. However, it is not called this because it is made up of 12 (*juuni*) layers. Regardless of the number of layers, the garment's significance lies in the luxury and aristocratic display that comes from the harmonious beauty of the layered colours. Today, the *sokutai* is worn for imperial ceremonies.

During this time, common people wore *kobakama* (trousers with tapered hems) that were easier to wear for farm work, and women wore short kimonos called *kosode*.

The Azuchi-Momoyama period was a vibrant era that greatly influenced the development of the kimono. As society transitioned from the aristocracy to a warrior class dominated by samurai, clothing became simpler and less elaborate. Women began to wear shorter-sleeved *kosode* paired with *hakama*. *Kosode*, which had been considered undergarments for the aristocrats during the Heian period, evolved as ceremonial garments. Clothing like the *karaginu* (hunting robe) worn by nobles was discarded,

CLASSICAL JAPAN

古典着物時代（大和〜江戸時代）

Heian court lady wearing twelve-layered jūni-hitoe
with a pale peach outer robe and orange undergarments.

CLASSICAL JAPAN

古典着物時代（大和〜江戸時代）

Heian-era layered jūni-hitoe *kimono with flowing silhouette depicting poetess Ono no Komachi in classical elegance.*

eventually becoming the prototype for the modern kimono. The emergence of the *kosode* (short-sleeved Japanese garment) is one of the most notable aspects of Japan's clothing history.

CLASSICAL JAPAN

古典着物時代（大和〜江戸時代）

Multi-layered silk robes with vibrant colours and elegant draping characteristic of noble Heian court fashion.

CLASSICAL JAPAN

Women enjoying autumn maple leaves under vibrant red trees at Takao Mt. in Azuchi-Momoyama period.

During this period, samurai sought to display their power and wealth through elaborate kimonos featuring luxurious patterns, while the *kosode* form remained unchanged. As well as aristocrats and samurai, merchants also began to gain wealth and social influence, leading townspeople to adopt increasingly ornate clothing.

Additionally, the tea ceremony flourished during the Azuchi-Momoyama period, especially under the influential tea master Sen no Rikyū. This led to the use of simple, subdued colours and designs, fostering a refined aesthetic that would carry over into the Edo period.

JOTARO SAITO

A contemporary kimono designer who fuses traditional dyeing and weaving with modern fashion, Jotaro Saito's creations feature bold, urban patterns and are often seen on fashion runways and in popular culture. His work has expanded globally to international audiences, redefining kimonos as a form of wearable art suitable for everyday.

CLASSICAL JAPAN

古典着物時代（大和〜江戸時代）

Toyotomi Hideyoshi and his five wives viewing cherry blossom at Higashiyama in Azuchi-Momoyama period.

Edo period (1603–1867)

The Edo period, which lasted for more than 200 years, was established by Tokugawa Ieyasu (1543–1616). A defining characteristic of the Edo period was the policy of '*sakoku*,' (national isolation), which prevented the influx of foreign cultures. Under the feudal system, strict social hierarchies of samurai, farmers, artisans and merchants were firmly established.

During the mid-to-late Edo period, merchants and artisans gradually gained economic power, which led to the growth of urban culture. This period saw cultural expression flourish through art forms primarily enjoyed by common people, such as *ukiyo-e* ('pictures of the floating world'), novels, haiku, *kabuki* and *joruri* puppet theatre.

A kimono pattern from the 'Tōsei hinagata' published in 1677, featuring a Kanbun kosode *design.*

CLASSICAL JAPAN

古典着物時代（大和〜江戸時代）

Grapes and vines depicted on a summer kosode *from the Edo period.*

The precursor of the modern kimono, known as the *kosode*, originated in the Heian period, underwent transformations in the Azuchi-Momoyama period and saw an expansion of its use during the Edo period. Particularly at the start of the Edo period, the *kosode*'s style altered, with changes in body width, sleeve length and sleeve breadth. Alongside the vibrant urban culture of Edo, the clothing culture became more refined. The emergence of decorative *obi* sashes further enriched this development.

This chapter explores the evolution of the *kosode* in the early and mid-Edo period, along with the impact of multiple edicts restricting displays of wealth issued by the shogunate and cultural influences, such as *kabuki* theatre, on the fashion culture of the Edo period.

CLASSICAL JAPAN

古典着物時代（大和〜江戸時代）

Noh costume patterned with impressed gold leaf and embroidered with silk in satin from Azuchi-Momoyama period.

CLASSICAL JAPAN

古典着物時代（大和〜江戸時代）

People playing cards in the Edo period. They are wearing uchikake *over their* kosode *kimonos.*

Keichō *Kosode*

The Keichō period spanned from 1596 to 1615, into the early part of the Edo era. The style of *kosode* (small-sleeved kimono) primarily created during this time is known as the Keichō style or Keichō *kosode*.

Unlike the bright, embroidery-focused *kosode* of the Momoyama period, the Keichō *kosode* is characterized by the use of *rinzu* fabric (silk satin damask) with a ground pattern. The garment was divided into large sections using sewing and *shibori* (tie-dying) techniques in circular, triangular, diamond and irregular shapes.

These sections were dyed in darker tones, such as black, white and crimson, and then further embellished with embroidery, *surihaku* (metallic

Kosode *with Shells and Sea Grasses pattern in the early Edo period.*

foil decoration), *kanoko shibori* (fine tie-dyeing) and other techniques. These decorations intricately portrayed motifs, such as flowers, birds and objects, with both precision and lavish detail. *Kosode* decorated so densely that the ground fabric is completely obscured are called 'groundless *kosode*' and are a typical example of the Keichō style.

The *kosode*'s form also evolved from the Momoyama era's wide-bodied, narrow-sleeved design to a more balanced silhouette, with body and sleeve widths nearly equal, bringing it closer to the modern kimono shape.

Kanbun *Kosode*

During the Kanbun period, from 1661 to 1673, the *kosode* style primarily created at this time is known as Kanbun style or Kanbun *kosode*.

Unlike the Keichō *kosode* that densely filled the fabric, leaving no white space, the Kanbun style is characterized by creating a contrast between negative space and patterns.

A key feature of Kanbun *kosode* is the bold and dynamic composition, where large motifs are arranged primarily from the left shoulder, cascading diagonally down the right front panel and continuing to the right hem. The left front panel is often left with ample negative space, resulting in a dramatic and vibrant design.

This spatial arrangement is believed to have influenced modern kimono styles, such as *houmongi* and *tsukesage*, which is why it is considered the prototype of the *eba-moyo* (picture-like patterns) found in contemporary designs.

CLASSICAL JAPAN

古典着物時代（大和〜江戸時代）

Kosode with Fishing Net and Characters, asymmetrical designs
such as this one were popular in the Kanbun period.

CLASSICAL JAPAN

古典着物時代（大和〜江戸時代）

*Bold phoenix design on vibrant red background with pine motifs,
typical of opulent Genroku style.*

The colour palette of Kanbun *kosode* became brighter, and the range of motifs expanded to include flowers, birds, natural landscapes, seasonal themes, objects and even characters. These patterns incorporated not only realistic depictions but also artistic and witty designs, making them unique to the Kanbun style.

Genroku *Kosode*

The Genroku period (1688–1704), in the mid-Edo era, was a time when the emerging merchant class gradually began to gain economic power and replace the samurai as cultural leaders.

With the growth of commerce, cities like Kyoto and Osaka saw a burgeoning of urban culture led by wealthy merchants during this time.

The kimono style that became popular at this time were known as Genroku or *hanami kosode*. These *kosode* featured rounded sleeves. Unlike the Kanbun patterns that emphasized negative space, Genroku patterns displayed bright colours and bold designs. Patterns often covered the entire garment or were arranged dramatically from the back to the hem.

Techniques such as *shibori* (tie-dyeing) and embroidery predominated, with generous use of gold thread, resulting in highly luxurious designs. Bold motifs such as latticework, stone pavements, *kanoko* dots (resembling spots found on the back of a fawn) and floral patterns are characteristic of Genroku *kosode*. Wealthy merchants from the Kamigata (Kyoto-Osaka) region commissioned increasingly elaborate and opulent *kosode*. During this period, the *kakie* (painted) *kosode* became popular, where

CLASSICAL JAPAN

古典着物時代（大和〜江戸時代）

A mid-Edo period kosode *with a gold embroidered chrysanthemum and pine tree pattern.*

Classical Japan

古典着物時代（大和〜江戸時代）

This painting showcases the intricate designs and elegant draping characteristic of kimonos from the Edo period.

artists were directly commissioned to create unique, one-of-a-kind designs.

Yūzen dyeing, which was introduced in the first chapter as a modern dyeing technique, was created by Miyazaki Yuzen-sai around this time. This beautiful technique was painted freehand and quickly gained popularity, revolutionizing the aesthetics of clothing and propelling Japanese fashion culture to new heights. Additionally, the *kosode* took a form almost identical to the modern kimono, making it a period when the *kosode* could be considered fully developed.

Classical Japan
Late Edo era

Until the Genroku period, the economic and cultural centre of Japan was located in the Kansai region (Kamigata). However, during the later Edo period, this hub shifted to Edo (modern-day Tokyo), and the urban merchant culture further developed and matured.

The design of the *kosode* type of kimono became simpler and more delicate compared to those from the Genroku period, reflecting an aesthetic aligned with Edo's sophisticated and understated style. This sense of *iki* (stylish simplicity) gradually permeated the general public.

Then, the string-like *obi*, which had previously played a practical role in fastening the kimono, gradually became wider and longer, and different types of *obi* with stronger decorative details and significance were born. During the Genroku period, *obi* of similar width and length to those worn today appeared, along with a variety of tying styles and positions.

With the emergence of these *obi*, new forms of design were developed, such as dividing patterns between the upper and lower halves of the garment at the *obi* line or placing patterns solely on the hem, incorporating the *obi* as a central feature of the overall design.

The most prevalent *obi* style today, the *taiko musubi* (drum knot), is said to have originated in 1813, when geisha from Fukagawa adopted this style of tying their *obi*. It was inspired by the reconstruction of the Taikobashi Bridge at Kameido Tenjin Shrine in Edo. It is also thought that around this time it become customary for women of all ages to tie their *obi* at the back, and the use of *obi-jime* (cords to secure the *obi*) became widespread.

CLASSICAL JAPAN

古典着物時代（大和〜江戸時代）

A gorgeous kosode *decorated with cherry blossoms, fences and carriage wheels.*

Classical Japan

The Impact of the Sumptuary Laws

The Edo period was characterized by a strict hierarchical class system of samurai, farmers, artisans and merchants (*shi-no-ko-sho*), and the aesthetics of the people were profoundly influenced by the sumptuary laws. These regulations, issued repeatedly during the mid-Edo period, aimed to restrict people's attire and lifestyle.

古典着物時代（大和〜江戸時代）

Woman in bright red kimono with white cherry blossoms; young man in teal patterned kimono.

CLASSICAL JAPAN

The sumptuary laws regarded silk as a luxury item and prohibited ordinary people from wearing materials other than cotton or hemp. Furthermore, they imposed detailed restrictions on colours, patterns and techniques used in clothing. These laws sought to curb extravagance, enforce simplicity and compel people to wear clothing suited to their social status.

古典着物時代（大和〜江戸時代）

Simple stripes reflect Edo-era modesty under sumptuary laws, limiting extravagant clothing.

CLASSICAL JAPAN

古典着物時代（大和〜江戸時代）

At the end of the Edo period, even young women's kimonos became dark in colour, with minimal patterns.

Out of these restrictions emerged the refined aesthetic of *Edo no iki* (Edo's sense of understated style) characterized by subtle elegance without outward opulence. This aesthetic celebrated intricate techniques and hidden luxury, appreciating refinement in elements that were not immediately visible.

Examples of this aesthetic include Edo *komon* (fine patterns dyed on fabric), *shijuhaccha hyakunezu* ('48 shades of brown and 100 shades of grey', symbolizing subdued colours) and *uramatsuri* (hidden embellishments on the inner side of clothing). These elements demonstrate the unique artistic values that were under the constraints of the sumptuary laws.

Edo *Komon*

The technique of *katazome* stencil dyeing, briefly introduced in Chapter 1, is central to Edo *komon*. Although its origins are said to date back to the Muromachi period (1336–1573), Edo *komon* developed significantly during the Edo period, when it was adopted for the patterns of *kamishimo* (formal samurai attire).

Due to the restrictions of the sumptuary laws, which banned bright colours and bold patterns, people began to use fabrics with subdued hues like brown and grey, decorated with extremely fine patterns, as a way of expressing their sense of style. These patterns were so minute that from a distance, the fabric appeared almost solid-coloured. The finer and more intricate the pattern, the greater the skill required by the artisan.

CLASSICAL JAPAN

Edo *komon* also served a uniform-like function, as the Tokugawa shogunate and individual domains designated specific patterns to represent their affiliations. The wearer's domain could be identified by the pattern of their attire. This practice was called *sadame komon* (regulated patterns), and wearing another domain's pattern was strictly forbidden. Among the most iconic Edo *komon* patterns are *same* (sharkskin), *kaku-tooshi* (square dots) and *gyogi* (orderly stripes), collectively referred to as the 'Three Great Patterns of Edo Komon'.

By the mid-Edo period, Edo *komon* extended beyond the samurai class to townspeople, giving rise to playful and imaginative patterns known as *iwaren komon*. These patterns featured motifs inspired by geometric shapes, nature, animals and other everyday objects.

Today, Edo *komon* remains a treasured tradition that is recognized as an Important Intangible Cultural Property. It continues to be popular as stylish attire for both men and women.

'*Shijuhaccha Hyakunezu*' and '*Uramasari*'

As strict regulations prevented ordinary people from wearing ostentatious clothing, their aesthetic desires shifted towards hidden layers, such as linings and undergarments, emphasizing what lay beneath the surface rather than the outer appearance. At the same time, the limited use of brown and grey tones allowed for the creation of a refined spectrum of colours, known as *shijuhaccha hyakunezu* ('48 shades of brown and 100 shades of grey').

CLASSICAL JAPAN

古典着物時代（大和〜江戸時代）

Late Edo period kimono with dark brown background featuring delicate embroidered fans and flowers.

Classical Japan

古典着物時代（大和〜江戸時代）

While maintaining a modest outward appearance, people indulged in luxurious linings, using techniques like crimson dyeing or *shibori* (tie-dyeing), a concept referred to as *uramasari* ('hidden splendour'). They took pleasure in a glimpse of vibrant lining peeking out from the collar or hem, and embraced an aesthetic of understated sophistication. This attention to unseen details and the joy of hidden creativity became a hallmark of the Japanese aesthetic, uniquely capturing the spirit of *iki* (stylish simplicity).

The townspeople of Edo further refined their approach to subdued hues, incorporating delicate and intricate variations within brown and grey tones, leading to the development of *shijuhaccha hyakunezu*. Though the name suggests '48 shades of brown and 100 shades of grey', it is said that each tone had more than 100 individual names. The numbers 48 and 100 were not literal counts, but rather symbolic expressions of the rich diversity within these colour families.

FUJII *SHIBORI*

Specializing in traditional *shibori* (tie-dyeing) techniques, Fujii *Shibori* is a Kyoto-based artisan brand. They combine centuries-old craftsmanship with fresh design sensibilities to create dynamic, textured kimonos. Known for innovation, they bring new life to *shibori* through collaborations, exhibitions and modern design applications.

CLASSICAL JAPAN

古典着物時代（大和〜江戸時代）

Edo komon *patterns are so fine that they appear plain from a distance.*

CLASSICAL JAPAN

古典着物時代（大和〜江戸時代）

A summer kimono from the late Edo period with a pattern of herons and reeds on the hem.

Classical Japan

This creative use of subtle colours and hidden beauty reflects a distinctly Japanese appreciation for nuance, restraint and ingenuity in the face of restriction.

古典着物時代（大和～江戸時代）

Because of sumptuary laws, members of the lower classes became creative with their kimono designs.

CLASSICAL JAPAN

古典着物時代（大和〜江戸時代）

Hatsune riding ground, Edo period (1615–1868).

CLASSICAL JAPAN

古典着物時代（大和〜江戸時代）

現近代着物時代（明治〜令和時代）

A striking 2016 Heisei-era kimono with a 3D geometric pattern, blending tradition and modern art.

CHAPTER 4

現近代着物時代
(明治～令和時代)

Modern Japan

Meiji period to Reiwa period (1868–Present)

Meiji period (1868–1912)

THE MEIJI ERA MARKED A significant transition from the Edo period, from a time of cultural developement under the policy of national isolation to an era of openness and Westernization spurred by the Meiji Restoration. During this period, lifestyles and clothing diversified and modernized at an unprecedented pace. In the Edo period, clothing symbolized the social class system, but with the opening up of the country and the introduction of foreign cultures, clothing in the Meiji period became a symbol of modernization and globalization.

In the late Edo period, the traditional attire of *kamishimo* was abolished and replaced by *montsuki hakama* (formal kimono with crested trousers). The

Modern Japan

現代近代着物時代（明治～令和時代）

government further encouraged Westernization through policies such as the *Danpatsurei* Edict of 1871 which allowed samurai to cut their topknots and introduced Western hairstyles in the early Meiji period. Later, the government mandated Western-style clothing for bureaucrats, military personnel and other officials during formal occasions, making Western clothing standard for men in public settings. For the general population, crested kimonos became the designated formal wear, establishing the practice of wearing kimonos as ceremonial attire – a tradition that continues today.

Meiji-era haori *with intricate woven lotus motifs, featuring a rich brocade and metallic threads.*

IUCHI SHOTEN

This innovative kimono shop blends tradition with modern practicality. Iuchi Shoten offers casual kimonos made of cotton and polyester and suitable for everyday wear. Utilizing digital textile printing, they can create one-of-a-kind kimonos and *obis* from a single piece. Their designs are playful, affordable and accessible for a younger clientele.

現代着物時代 (明治〜令和時代)

Three girls, c. 1880s, photograph taken by Kusakabe Kimbei.

Modern Japan

現代着物時代 (明治〜令和時代)

The elegant silk summer kimono with auspicious cranes and pines is carefully hand-painted against sunrise.

MODERN JAPAN

現代着物時代（明治〜令和時代）

Early Meiji period kimonos often have a dark ground and decoration concentrated along the hemline.

MODERN JAPAN

現代近代着物時代（明治〜令和時代）

Montsuki hakama (a haori *and* hakama *with family crest) such as this one is formal attire for men.*

Modern Japan

現代着物時代（明治〜令和時代）

While men quickly adopted Western clothing, women in the Meiji era primarily wore traditional Japanese clothing in their daily lives. Over time, they began incorporating Western elements, creating a blend of Japanese and Western styles. At this time, Western clothing was still expensive, so commoners mostly wore traditional Japanese garments.

Two main types of *kosode* (short-sleeved kimonos) were carried over from the Edo period to the Meiji era. One type featured vibrant embroidery and *shibori* (tie-dyeing) was favoured by wealthy merchants in the late Edo period and was used for formal garments like *furisode* and *uchikake*. The other type was more subdued, with muted base colours and decorative patterns created through yūzen dyeing and embroidery, often worn by townspeople.

Women's kimonos with longer sleeves gradually evolved, along with wider *maru obi* (sashes) and accessories like Western-style bags and parasols.

'Concert of European Music' (Ōshū kangengaku gassō no zu), artwork from 1889.

Modern Japan

Additionally, *haori* (short jackets), originally men's clothing, began to be worn by women, starting with geishas in Fukagawa during the late Edo period. Although temporarily banned by the Tokugawa shogunate, *haori* became popular among women in the Meiji era. Women's *haori* styles varied over time, with long-length *haori* being particularly fashionable during this period.

Student Attire

From the mid-Meiji period, a style known as *shosei* (student attire) became popular among male students. This outfit typically included a patterned kimono, *hakama*, *haori* and a straw hat. Outerwear, such as Inverness coats and *tonbi* (a sleeveless cape-like cloak), became widespread among men regardless of whether they wore Japanese or Western clothing.

In the late Meiji period, educational institutions for women were established. As a result, more practical clothing, such as *hakama* (split skirts), replaced traditional kimonos and sashes for female students. A hairstyle called *hisashi-gami*, characterized by a fringe and sidelocks styled forward, became a major trend. Female students often paired this hairstyle with reddish-brown *hakama* and lace-up boots, forming the quintessential look for women in education during this time.

MODERN JAPAN

現代着物時代（明治〜令和時代）

Meiji-era uchikake *featuring* **Kakuremino** *(magical cloak) motif, symbolizing protection and good fortune.*

157

Modern Japan

現代着物時代（明治～令和時代）

Meiji-era royal women in colourful silk kimono enjoying cherry blossoms at Benten Shrine, Ueno.

MODERN JAPAN

現代着物時代（明治〜令和時代）

159

Modern Japan

現近代着物時代（明治〜令和時代）

Young Meiji-era woman wearing kimono, hakama *and a traditional hair ornament.*

MODERN JAPAN

現代着物時代（明治〜令和時代）

'Paper Doll Clothing', woodblock prints from the Meiji era, 1897–1898.

Modern Japan
Taishō Era (1912–26)

The Taishō era lasted only 15 years, but it was a period marked by significant events, such as the outbreak of World War I and the Great Kanto Earthquake, which had a magnitude of 7.9 and killed more than 100,000 people. It was also a very important turning point in Japanese fashion.

The Western fashion culture introduced during the Meiji era became even more deeply ingrained in the Taishō era. With the rise of liberalism and individualism, women's social advancement and cultural diversity progressed as well. Modern girls began to favour short haircuts and wear Western-style clothing and makeup. However, it wasn't until later that Western-style clothing for women became widespread; initially, it was only a fashion among the upper class and wealthy women.

An obi from the Taishō era featuring a design of fish and marine objects (left – front, right – back).

MODERN JAPAN

現代着物時代（明治〜令和時代）

Geisha with traditional shimada *hairstyle, a floral kimono and yellow* obi *from the Meiji–Taisho transition era.*

Modern Japan

現代着物時代（明治〜令和時代）

Iconic beauty portrait by Yumeji Takehisa, a poet-artist of Taisho Romanticism.

Modern Japan 現代着物時代（明治～令和時代）

In the early Taishō period, kimono styles such as *omeshi*, *meisen*, Oshima *tsumugi* and *kihi* were popular, with many muted colours, a remnant of the Meiji era. However, as the era progressed, Western art movements like Art Nouveau and Art Deco influenced the patterns of traditional kimono fabrics and *obi* designs. Bold and colourful designs reflected the Taisho Roman cultural movement, especially among young people and women. Yumeji Takehisa and Takabatake Kansai were prominent artists and illustrators in this movement.

Yumeji Takehisa established a unique style of female portraits art, known as 'Yumeji-style beauties', and became famous through lyrical and evocative illustrated books of his art. Takabatake Kansai's 'Kansai style' also became an object of admiration to many people.

Women and girls sorting and grading tea leaves, c. 1920

Modern Japan
現近代着物時代（明治〜令和時代）

However, as a reaction to the rapid Westernization of the Meiji era, there was a movement in the Taishō era to reclaim Japan's cultural identity. As part of this movement, the Mitsukoshi department store introduced the *hōmongi* (visiting kimono), which is considered a precursor to modern semi-formal wear. It was designed to be worn for social visits, filling the need for a kimono that would be appropriate for such occasions. The *hōmongi* was a hybrid between casual and formal attire similar to an afternoon dress in Western dress.

Since the Meiji era, kimono designs generally featured small patterns or motifs across the entire garment. However, *hōmongi* featured designs that extended from the hem to the sleeves, shoulders and collar, often with a family crest in three places (*mitsu-monzukuri*).

Additionally, the 'Nagoya *obi*' – an *obi* where the width of the part wrapped around the torso is halved while the drum knot portion remains full width – is currently the most common type of *obi* and was created during the Taishō era. It was invented by the founder of Nagoya Girl's School (now Nagoya Women's University), after which it is named.

MODERN JAPAN

現代着物時代（明治〜令和時代）

Wavy hair, which became popular in Europe during the Taisho era, also spread to Japan at this time.

Modern Japan

現代着物時代（明治〜令和時代）

'Ladies sewing' (Kijo saihō no zu), 1887.

MODERN JAPAN

近現代着物時代（明治〜令和時代）

Modern Japan
Shōwa Period (1926–1989)

The Shōwa era can be broadly divided into pre-war and post-war periods relating to World War II. Pre-war Japan, following the economic development of the Taishō era and the arrival of Western companies, once again featured glamorous Western art, entertainment and fashion. Unlike the Taishō era, during which Westernization had temporarily slowed down, the Shōwa period saw an acceleration of Westernization.

In terms of fashion culture, pre-war early Shōwa Japan inherited the Taishō romantic style and saw the blossoming of a hybrid Japanese-Western culture known as 'Shōwa Modern', which fused modern Western culture with Japanese traditions.

現近代着物時代（明治〜令和時代）

'Utatane' うたつ寝, *'a nap' by Torii Kotondo, 1933.*

MODERN JAPAN

現代着物時代（明治～令和時代）

Young lady in yellow furisode *kimono with fans, an early Shōwa period illustration by Takabatake Kasho.*

Modern Japan

現代着物時代（明治〜令和時代）

Pre-war kimono fashions continued the Taishō era's trend of vibrant Art Deco-style geometric patterns, and in the early Shōwa period, kimonos incorporating bold Western-inspired designs became especially popular.

Additionally, *meisen* kimonos (made of silk-like fabric) became extremely popular, loved by common people as everyday wear due to their affordable price and freeflowing design. Shōwa period kimonos were dominated by casual wear (like *meisen* and wool) and formal wear (such as *houmongi* and *furisode*).

The *Maru-obi* (a thick belt of folded fabric approximately 70cm/27in wide), which appeared in the mid-Edo period, was considered the most formal *obi*. Until the early Shōwa period, all obis were in the *Maru-obi* style.

A traditional obi design from the Shōwa period, c. 1930s.

MODERN JAPAN

現代着物時代（明治〜令和時代）

The combination of bold geometric patterns and vibrant colors creates an energetic meisen *kimono.*

Modern Japan

現近代着物時代（明治〜令和時代）

The Nagoya *obi*, created in the Taishō era, became even more widespread during the Shōwa period. Also, around this time, the 'Fukuro Nagoya *obi*' – a lightweight, easy-to-tie belt made without a stiff core and sewn at the edges – was invented and became popular. This type of *obi* is still worn today. From the Taishō era into the Shōwa period, the spread of chemical dyes and improvements in dyeing techniques made it possible to mass-produce vibrantly coloured kimonos.

Omeshi *kimono and* Nagoya obi *from the Shōwa era.*

MODERN JAPAN

現代着物時代（明治〜令和時代）

Advertising postcard for the Koraku department store, Tokyo, 1920s.

Modern Japan

現近代着物時代（明治〜令和時代）

In the 1960s, many mothers wore black *haori* with family crests to their children's school entrance and graduation ceremonies. During this period, shorter-length *haori* were also in fashion. Before the war, nearly all women could sew their own kimonos, *obi*s, and *hakama* sets, but after the war, this skill declined as people stopped wearing kimonos.

Social changes were a major factor in the shift from Japanese to Western clothing. The Shirokiya department store fire in 1932 was a significant turning point that led to the adoption of women's Western-style clothing. Many of the Shirokiya female employees wore kimonos with highly inflammable *obi*s. It is thought that as kimonos restricted movement, this was a factor that delayed the women's escape from the burning building. At that time, women wore

A 1939 advertisement for Kirin beer, epitomising the rising tide of militarism and fascism in Japan.

MODERN JAPAN

現代着物時代（明治〜令和時代）

Japanese woman in a kimono walking with boy in a Western suit during the early Shōwa period.

Modern Japan

現近代着物時代（明治〜令和時代）

traditional Japanese underskirts beneath their kimonos, but some women, embarrassed about their undergarments being visible, hesitated to evacuate the higher floors and fell to their death. This tragic event helped people recognize the importance of easy-to-move-in clothing, and Western-style clothing became more widespread among the general public.

During this period, many women wore kimonos at home but chose Western attire at work and for outings. Additionally, 'improved clothing' (*kairyō sa reta ifuku*) – a hybrid style that arranged Western-style jackets and skirts with Japanese elements – became popular, as it prioritized women's ability to work comfortably.

When World War II began in 1939, women's modesty became primary, and glamorous Western-style fashion went into hiding. As the war intensified,

Female high school students wearing kimonos with family crests and hakama *in the early Shōwa period.*

MODERN JAPAN

現代着物時代（明治〜令和時代）

A servant helps a young woman in Japan to put on her kimono, c. 1940s.

Modern Japan

現近代着物時代（明治〜令和時代）

clothing came under government control due to material shortages. For men, the standard became military-coloured matching tops and bottoms, while women typically wore kimonos with *monpe* (women's work trousers). To conserve resources, simplified clothing was recommended, and basic Western-style clothing was encouraged over kimonos, which required more fabric. In 1945, when the war ended, severe shortages continued, the country was poor and women could not afford the luxury of fashion.

A female worker in Japan, image from the early 20th century.

MODERN JAPAN

現代着物時代（明治〜令和時代）

A munitions worker during the Second World War, Japanese women played a significant role in the war effort.

MODERN JAPAN

現代着物時代（明治〜令和時代）

A woman walking through Ginza wearing 1930s fashion.

MODERN JAPAN

現近代着物時代（明治〜令和時代）

After the war, during the Shōwa era, it was still common to see women wearing kimonos.

MODERN JAPAN

トランプ

現代着物時代（明治〜令和時代）

Illustrations from a post-war, Shōwa-period girls' magazine.

MODERN JAPAN

現代着物時代（明治〜令和時代）

A girl with Western-style hair and a ribbon wearing a kimono.

Modern Japan

現代着物時代（明治〜令和時代）

An illustration by Nakahara Junichi, a painter and designer who continued to lead women's culture after the war.

Modern Japan

現代近代着物時代（明治〜令和時代）

In 1946, the year after the war ended, when the whole country was still in a state of confusion and depression following the country's defeat, Warabi City in Saitama Prefecture held a youth festival to encourage and inspire young people as the leaders of the next generation. This event drew the attention of national and regional government, leading to the establishment of today's Coming of Age Day ceremony celebrating adulthood.

That same year, the women's fashion magazine *Soleil* was launched, inspiring the imagination of many women. The magazine's founder was Junichi Nakahara, a graphic artist who had taken the girls' magazine world by storm with his groundbreaking illustrations. Nakahara's detailed illustrations of kimonos, Western clothes, hairstyles and lifestyle suggestions showed women how to 'live beautifully and enjoyably without spending much money', and he was a major inspiration for women's rediscovery of the joys of fashion.

During the post-war period of Allied occupation, American culture was introduced, women's status improved and economic controls were lifted, which gradually resulted in women being freer to choose more functional clothing. By the mid-1950s, more Western fashion was being worn than traditional Japanese clothing in urban areas. After the war, kimonos were

Modern Japan

現代着物時代（明治〜令和時代）

Homongi with painted yuzen decoration of flower balls of peonies, chrysanthemums motifs with embroidered detailing in colorful threads.

MODERN JAPAN

現代着物時代（明治〜令和時代）

*In the Heisei and Reiwa period, young girls enjoy
wearing Shōwa-period vintage styles in a new, contemporary way.*

Modern Japan

gradually worn less as everyday clothing and only remained as formal wear for special occasions.

Until the economic boom during the latter half of the Shōwa era, it was customary for parents to provide their children with a complete set of kimonos as essential items for ceremonial occasions like weddings and funerals when they got married. While kimonos were still commonly worn at formal occasions, this practice gradually declined as well.

Previously, mothers and grandmothers had taught younger generations how to wear kimonos, but as older generations stopped wearing them, people began learning how to wear kimonos at special dressing schools instead. As such, the kimono became increasingly removed from everyday Japanese life.

The Heisei Era and Beyond (1989–2019) & the Reiwa Era (2020–)

Since the Heisei era, while preserving tradition, 'casual kimono' culture has spread, making the kimono more suited to modern lifestyles. New textiles besides silk, such as cotton and synthetic fibres, were introduced, allowing kimonos to be worn daily as casual wear.

Since 2000, there has been a popular nostalgia for vintage kimonos with Taishō Romance and Shōwa Modern designs. During this time, several casual kimono magazines were also launched.

MODERN JAPAN

現代着物時代（明治～令和時代）

A kimono from the Heisei period with a haori *from the Shōwa period, garments also worn in the Reiwa period.*

Modern Japan

This boom popularized kimonos with modern designs, pop art patterns and retro elements. A fashion trend emerged whereby people could acquire recycled or vintage kimonos at affordable prices. Vintage shops and rental shops increased, and kimono dressing schools spread nationwide. The growth of the internet and social media enabled people to research and buy kimonos online and form their own kimono communities.

Since the Heisei era, the improved quality of synthetic fibres like polyester and advanced digital inkjet printing technology have led to the rapid spread of machine-washable kimonos. As a result, *tsumugi* (pongee silk) and cotton kimonos reappeared, and casual kimonos made from Western fabrics like denim became popular. Digital printing technology also brought significant change by enabling small-scale production.

Yukata, which are easier to wear compared to other types of kimono, are extremely popular, and it has become traditional to wear them to summer festivals and firework displays every year. Originally, *yukata* – cotton kimonos worn after bathing in the Edo period – were intended to be worn in the evening to keep cool. However, today, *yukata* are becoming indistinguishable from summer kimonos, and they are worn as casual outerwear.

In the Reiwa era, continuing the Heisei trends, there has been an increase in fusion coordinates that combine Western clothes with the kimono, new ideas for pre-tied *obi* have emerged, and there's a growing trend to enjoy the kimono as fashion and with greater creative freedom. On the other hand, the expansion in demand for traditional artisan kimonos that was seen during periods of high economic growth has disappeared. The spread of rental kimonos for special occasions, such as graduation, Coming of Age ceremonies

MODERN JAPAN

現代着物時代（明治〜令和時代）

Printing technology improved significantly in the Heisei and Reiwa periods, creating beautiful colours and designs.

193

Modern Japan

現近代着物時代（明治〜令和時代）

and weddings, has made it common for most people to rent outfits rather than buy. Additionally, the tradition of giving kimonos to daughters upon their marriage has gradually disappeared over time. As a result, fewer and fewer people are purchasing traditionally crafted kimonos that have been passed down for generations.

Unfortunately, crafts including Yūzen dyeing, stencil dyeing, *tsumugi* weaving and dyeing, which have existed since the Edo period – along with textile makers, dyers, tailors, and their supporting industries – are steadily declining. How to preserve these traditional techniques, and how the kimono industry should evolve, remain significant challenges.

This homongi *was made for the author 40 years ago, and the beautiful, timeless design allows it to be worn across many decades. The next generation will high-quality pieces such as this with enduring appeal.*

MODERN JAPAN

現代着物時代（明治〜令和時代）

With geometric patterns, floral woven obis, *and half collars featuring card patterns, kimono designs are always fun in the Reiwa era.*

Women in the Edo period visiting a shrine with their 30-day-old infants.

CHAPTER 5

人生の節目を彩る着物

Kimonos for Life Milestones: from Birth to Death

J‍APANESE PEOPLE WEAR DIFFERENT TYPES of kimono at various stages of life, from birth to death, with each kimono carrying specific ceremonial and cultural significance. Although these customs have declined due to modernization and for practical reasons, this chapter explains the history of each ceremony and the types of kimono worn for these milestone occasions.

Birth and *Miyamairi* (First Shrine Visit)

Miyamairi is a traditional Shinto rite of passage where parents take their babies to a shrine to celebrate their birth and pray for good health and development. Its origins date back to the Heian period, when aristocrats would present their children to the family deity and ask for divine protection. From the

人生の節目を彩る着物

KIMONOS FOR LIFE MILESTONES

Muromachi to Edo periods, this custom spread to samurai and common people, developing regional variations. Due to high infant mortality rates in the past, receiving blessings at a shrine was considered particularly important. The timing and format of the ceremony varies by region. Generally, the visit takes place around 30 days after birth, though some places specify the 31st day for boys and the 33rd day for girls. For today's *Miyamairi*, babies wear ceremonial clothes (*iwai-gi* or *kake-gi*) decorated with auspicious motifs like cranes, turtles and pine-bamboo-plum patterns. Mothers wear formal kimono, such as visiting wear (*homongi*) or plain-coloured kimonos (*iromuji*). After the shrine visit, families take commemorative photos and enjoy celebratory meals with relatives.

During the Meiji period, people gather to celebrate the birth of a child.

KIMONOS FOR LIFE MILESTONES

人生の節目を彩る着物

Girl's Miyamairi *kimono with cranes over water, for their first visit to a Shinto shrine.*

Kimonos for Life Milestones

人生の節目を彩る着物

Shichi-Go-San (Seven-Five-Three Ceremony)

Like *Miyamairi*, *Shichi-Go-San* is a traditional Japanese ceremony that celebrates children's growth in which prayers are said for their healthy future. Its origins lie in the aristocratic customs of the Heian period: the ceremony of starting to grow out previously-shaved hair at age three, boys wearing *hakama* for the first time at age five, and girls transitioning from children's string-fastened kimono to adult-style *obi* at age seven. Since young children's survival was very difficult in those times, ceremonies were held at these milestone ages to thank the gods and pray for continued growth.

This custom became established primarily among samurai families during the Muromachi and Edo periods. It spread to common people after the Meiji era, when the Meiji government's promotion of the Shinto religion made it popular for families to visit shrines with their children.

A family dressed in traditional kimonos for Shichi-Go-San *in the 1950s.*

KIMONOS FOR LIFE MILESTONES

人生の節目を彩る着物

Seven-year-old girls dressed for Shichi-Go-San *festival during the Shōwa period.*

Kimonos for Life Milestones

人生の節目を彩る着物

Today, *Shichi-Go-San* remains an important family event to celebrate children's growth and pray for their health and happiness (for girls at ages three and seven, and for boys at age five). The ceremony is marked by shrine visits and family photos at photography studios.

Three-year-old girls wear kimonos with *hifu* (an overcoat). Five-year-old boys wear *haori-hakama* decorated with auspicious, powerful motifs like pine trees, hawks and helmets. Seven-year-old girls wear formal kimonos with *obi*s.

Children wear *yotsumi* kimonos, which are designed for ages four–twelve. *Yotsumi* is made from cloth four times the child's height, with adjustable length and sleeve length to accommodate future growth. The shoulder tucks (*kata-age*) that adjust the shoulder width symbolize the child's future growth – conversely, the absence of shoulder tucks would imply 'no more growth', so *Shichi-Go-San* kimonos typically include shoulder tucks to wish for the child's continued growth.

Mothers wear formal kimonos, such as visiting wear (*homongi*) or plain-coloured kimonos (*iromuji*) for the shrine visit.

Jusan Mairi (Thirteenth Year Shrine Visit)

Jusan Mairi is a ceremony where 13-year-old boys and girls (by the traditional Japanese counting system) visit the Japanese deity Kokuzō Bosatsu to ward off misfortune, receive wisdom and good fortune and pray for healthy growth.

KIMONOS FOR LIFE MILESTONES

人生の節目を彩る着物

Five-year-old boy wearing men's formal attire: a haori *and* hakama.

Kimonos for Life Milestones

人生の節目を彩る着物

This custom reportedly began when Emperor Seiwa visited the Kokuzō Bosatsu at Hōrin-ji Temple in Kyoto for his Coming of Age ceremony at age 13, during the Heian period. The main deity of Hōrin-ji, Kokuzō Bosatsu, is considered the Bodhisattva of wisdom and good fortune, and it was believed that visiting on the 13th day of the 3rd month of the lunar calendar (Kokuzō Bosatsu's special day) would grant wisdom.

As Jusan Mairi marks the entry into adulthood, girls traditionally changed from children's *yotsumi* kimono to adult-sized *hontachi* kimonos. Boys wore formal *montsuki haori-hakama*, the same as adult men's formal wear.

Formally, the kimono is worn with shoulder tucks on the day of Jusan Mairi, and the tucks are removed after the visit. Traditionally, visitors would copy sutras (Buddhist texts) as offerings, but today, they typically offer copies of single-character sutras. It is also believed that at the shrine one should not look back after prayers, as doing so may cause the received wisdom to be taken away.

Coming of Age Ceremony

The roots of the Coming of Age ceremony trace back to the *genpuku* ritual performed from the Nara to Heian periods. The modern Coming of Age ceremony spread nationwide after a ceremony was held in Saitama Prefecture in 1946 to encourage 20-year-olds during the post-war chaos, and Coming of Age Day was established as a national holiday in 1948.

KIMONOS FOR LIFE MILESTONES

人生の節目を彩る着物

At age thirteen, children visit a temple to pray to Kokūzō Bosatsu for wisdom.

205

Kimonos for Life Milestones

人生の節目を彩る着物

In 2022, the age of majority was lowered from 20 to 18, and the current Coming of Age ceremony now celebrates men and women who have turned 18.

At this ceremony, women wear elaborate *furisode*, the formal kimono for unmarried women. Although men increasingly wear suits today, traditionally they wear *haori-hakama* for Coming of Age Day. On this day, young people in elaborate kimonos can be seen celebrating this important custom throughout the country.

Graduation Ceremony

The custom of wearing *hakama* at graduation ceremonies spread from the late Meiji period, when women's education was encouraged and became widespread. In an era when Japanese clothing was the norm rather than Western clothing, *hakama* was recommended as practical attire for female students as new girls' schools were established, and it became customary as formal wear for female students. Around the late 1880s, it became popular to wear *hakama* at landmark events like graduation ceremonies. *Hakama* also acted as a symbol of hope and independence for women of that era, and this significance continues today. In modern Japan, it has become common, particularly for women, to wear elaborate kimonos and *hakama* at university and junior college graduation ceremonies.

KIMONOS FOR LIFE MILESTONES

人生の節目を彩る着物

Young women wear colourful furisode *kimonos and* obi *knots such as this one for their Coming of Age Day ceremony.*

KIMONOS FOR LIFE MILESTONES

人生の節目を彩る着物

A man wearing a black crested kimono and hakama *at his Coming of Age ceremony.*

Kimonos for Life Milestones

Wedding Ceremonies

Marriage has always been one of life's most important milestones. The wearing of traditional Japanese wedding attire, such as *shiromuku* (white kimono) and *iro-uchikake* (coloured outer robe) primarily began during the Edo period. White kimonos began to be worn at weddings and ceremonies among nobles as a sacred and pure colour in the 1500s. During the Edo period, *shiromuku* became established as bridal wear at samurai wedding ceremonies. *Shiromuku* represents purity and symbolizes the bride's readiness to be 'dyed in the colours' of her new family.

Iro-uchikake began to be used as luxurious wedding attire from the Azuchi–Momoyama period through to the Edo period. During the Edo era, it became customary for brides to wear elaborate *uchikake* over their kimonos

A traditional men's hakama.

人生の節目を彩る着物

Kimonos for Life Milestones

人生の節目を彩る着物

For graduation ceremonies, girls wear elegant kimonos with long sleeves (around 76.2cm or 30in) and hakama *trousers.*

KIMONOS FOR LIFE MILESTONES

人生の節目を彩る着物

Women's hakama *are skirt-like pleated trousers traditionally worn over kimono.*

人生の節目を彩る着物

at receptions and post-wedding celebrations. *Iro-uchikake* signified wealthy households and demonstrated a family's prosperity and beauty.

From the late Edo period to the early Meiji period, brides began wearing black *furisode*. These featured trailing designs with vibrant embroidery and dyed patterns, with the black background highlighting the family crest and indicating the family's status.

After the Meiji period, traditional Japanese dress was combined with Western styles in wedding attire. After the Taishō period, the use of black *furisode* at weddings gradually decreased, and *shiromuku* and *iro-uchikake* became firmly established as wedding attire. Brides today often combine traditional Japanese garments of *shiromuku* and *iro-uchikake* with Western-style dresses. Traditionally,

A Meiji-era bride being dressed in traditional white wedding kimono for her ceremony.

Kimonos for Life Milestones

人生の節目を彩る着物

Traditional white bridal uchikake *with Phoenixes and Paulownia, symbolizing purity, elegance and good fortune.*

人生の節目を彩る着物

grooms have worn black *montsuki haori-hakama* with family crests, but today, they may wear the same combination of garments but in different colours.

Funeral Attire

Specific funeral clothes are worn for mourning the deceased and by funeral attendees offering prayers. While black mourning clothes are common today, there was a time in Japan when only white mourning clothes were worn. In Shinto, white traditionally symbolized 'purity' and 'purification'. From ancient times and through the Heian period, white was used at funerals and mourning rituals for the sacred ceremonies to purify death's impurity. In Edo-period samurai society, white attire also symbolized loyalty and integrity, and both men and women wore white mourning clothes. Until the Meiji period, commoners wore white mourning clothes for over 1000 years in Japan.

Kimonos for Life Milestones

人生の節目を彩る着物

A wedding kimono decorated with auspicious patterns of bamboo, pine and plum blossoms all over.

215

KIMONOS FOR LIFE MILESTONES

The change from white to black mourning clothes came during the Meiji period with the rising influence of Western dress. When state funerals were held for government officials and imperial family members, Western guests wore black mourning clothes, which led upper-class Japanese to adopt similar black attire as uniform. However, black mourning clothes did not spread among ordinary people until World War II. With growing numbers of war casualties and subsequent funerals, people gradually began wearing black mourning clothes as they were easier to maintain and showed less dirt.

Today, while traditional Japanese mourning clothes are mostly worn only by immediate family members at funerals, the formal attire consists of all-black items, including kimono, *obi*, *obi-age*, *obi-jime* and *zōri*. In some regions, white mourning clothes are still worn.

Burial Kimono

According to Japanese tradition, while death is considered impure, it was believed that after death, the soul becomes pure and journeys to the afterlife. Though practices vary by Japanese tradition, regional custom and religion, the special attire the deceased usually wears is a burial kimono called *shinishozuku*.

Kimonos for Life Milestones

人生の節目を彩る着物

Japanese funeral procession during Meiji period, with mourners dressed in white kimono.

KIMONOS FOR LIFE MILESTONES

人生の節目を彩る着物

Traditionally, the deceased wears '*kyō-katabira*' (a white kimono worn by Buddhist ascetics) as they are considered to be departing for the Pure Land.

There are several theories as to why the burial kimono is white: because pilgrims traditionally wore white, because it symbolizes new beginnings and because white represents rebirth. The burial kimono is dressed with the right side over the left, the opposite to normal kimono-wearing. This is because the afterlife is considered the opposite world to this one, and in modern times, it serves to distinguish the deceased from the living. The deceased is dressed in white *tabi* socks, *kyahan* (leg wraps), *tekkō* (hand covers) and *waraji* (straw sandals). A *zudabukuro* (money pouch) containing six coins is placed in the coffin. The hood is placed at the head of the coffin. It was traditionally believed that the Sanzu River flowed between this world and the afterlife, and the custom of placing six coins in the *zudabukuro* as a ferry fare for crossing the Sanzu River emerged during the Edo period and continues today. Thus, death is considered a journey to the afterlife and the custom of preparing and sending off the deceased with travel equipment remains.

In Japan today, burial attire has been simplified. The traditional white burial attire is sometimes omitted, and it has become more common to dress the deceased in their favourite clothes or kimono.

Kimonos for Life Milestones

人生の節目を彩る着物

Japanese funeral home.

Kimonos for Life Milestones

人生の節目を彩る着物

- Straw hat 編笠
- Head cloth 天冠
- Prayer beads 数珠
- Gauntlets (protective gloves) 手甲
- Leg wraps 脚絆
- White kimono 白帷子
- Money pouch 頭陀袋
- Six coins 六文錢
- Walking stick 杖
- Tabi socks 足袋
- Sandals 草履

Buddhist–style (仏式) Japanese burial garments.

Periods of Japanese History

JŌMON
c. 14,000–300 BCE

YAYOI
300 BCE–300 CE

YAMATO
c. 300–710 CE

ASUKA
538–710 CE

NARA
710–794 CE

HEIAN
794–1185 CE

KAMAKURA
c. 1192–1333

MUROMACHI (ASHIKAGA)
1336–1573

AZUCHI–MOMOYAMA
1573–1603

EDO (TOKUGAWA)
1603–1867

MEIJI
1868–1912

TAISHŌ
1912–1926

SHŌWA
1926–1989

HEISEI
1989–2019

REIWA
2019–PRESENT

Glossary

Aizome 藍染 indigo dyeing
Arimatsu Narumi Shibori 有松鳴海絞り traditional tie-dyeing technique
Asanoha 麻の葉 hemp leaves
Atozome 後染め post-dyeing
Dokko 独鈷 Buddhist ritual tool
Eba-moyo 絵羽模様 picture-like patterns
Edo Komon 江戸小紋 fine patterns dyed on fabric
Edo Sarasa 江戸更紗 Edo chintz pattern
Fukura-suzume 福良雀 plump sparrow
Fukuro obi 袋帯 simplified, light obi
Furisode 振袖 formal kimono for unmarried women
Genroku Kosode 元禄小袖 kosode worn during Genroku period (1688–1704)
Gyogi 行儀 orderly stripes
Hakata Kenjo 博多献上 Japanese woven textile
Hakata Ori 博多織 Japanese woven textile
Haori 羽織 short jackets
Heko obi 兵児帯 soft obi from the Meiji era
Hifu 被布 an overcoat
Houmongi 訪問着 semi-formal kimono
Hyotan 瓢箪 gourd
Ichimatsu 市松 checkered pattern
Iki 粋 stylish simplicity
Iro-uchikake 色打掛 coloured outer robe
Iromuji 色無地 plain colour formal kimono
Irotomesode 色留袖 coloured formal kimono
Ise katagami 伊勢型紙 craft of making paper stencils for dyeing textiles
Ise Momen 伊勢木綿 soft texture thread
Iwai-gi 祝い着 ceremonial clothes
Junichi Nakahara 中原淳一 graphic artist and fashion designer
Jusan Mairi 十三参り thirteenth year shrine visit
Juunihitoe 十二単衣 layered clothing
Kabuki 歌舞伎 classical Japanese theatre
Kachi-mushi 勝虫 victory insects
Kaga Goshiki 加賀五色 five colours of Kaga
Kaga Yuzen 加賀友禅 dyeing technique using five colours
Kagome 籠目 basket weave
Kai-zukushi 貝尽くし seashells motif
Kaku obi 角帯 woven men's obi
Kaku-tooshi 角通し square dots
Kamigata 上方 Kansai region
Kamishimo 裃 formal samurai attire
Kamon 家紋 family crests
Kanbun Kosode 寛文小袖 kosode worn in the Kanbun period (1661–1673)
Kanoko Shibori 鹿の子絞り tie-dyeing from Edo period
Kanto-i 貫頭衣 a piece of clothing with a hole for the head
Kanze-mizu 観世水 kanze water
Karakusa 唐草 arabesque
Kasho Takabatake 高畠華宵 Japanese artist
Kasuri 絣 technique for pre-dyed kimono
Kataezome 型絵染 picture stencil dyeing
Katamono かたもの woven kimonos
Katazome 型染 stencil dyeing
Keicho Kosode 慶長小袖 kosode worn in the Keichō period (1596–1615)
Kikko 亀甲 tortoise shell
Kimono 着物 traditional Japanese garment
Kiryu Ori 桐生織 Kiryu weaving
Kissho monyo 吉祥文様 auspicious patterns
Kobakama 小袴 trousers with tapered hems
Komon 小紋 a kimono dyed with a simple repeating pattern
Kosode 小袖 short-sleeved kimono
Kuginuki tsumugi 釘抜紬 nail-resistant tsumugi
Kumodori 雲取り cloud pattern
Kurotomesode 黒留袖 black formal kimono
Kurume Kasuri 久留米絣 technique for pre-dyed kimono

Kyo yuzen 京友禅 hand dyeing technique
Kyo-katabira 経帷子
 white kimono worn by the deceased
Maru obi 丸帯
 prestigious obi from Edo period
Matsu-Take-Ume 松竹梅 pine, bamboo and plum
Meisen 銘仙 silk fabric
Miyamairi 宮参り first shrine visit
Miyazaki Yuzensai 宮崎友禅斎
 a fan painter in the Edo period
Momen 木綿 cotton
Montsuki hakama 紋付袴
 formal kimono with crested trousers
Montsuki haori-hakama 紋付羽織袴 formal wear for grooms at weddings
Mushikui 虫喰い insect-eaten
Nagoya obi 名古屋帯
 casual obi from Taishō era
Nanten 南天 nandina – sacred bamboo
Nishijin Omeshi 西陣お召
 high quality fabric from Kyoto
Nishijin Ori 西陣織 textile produced in Nishijin region of Kyoto
Obi 帯 belt worn with kimonos
Obi-age 帯揚げ scarf-like cloth worn above the obi
Obi-jime 帯締め cords to secure the obi
Ogi 扇 fan
Omeshi お召
Oshidori 鴛鴦 thick crepe fabric
Oshima tsumugi 大島紬 dyed silk textile
Rinzu 綸子 silk satin fabric
Ryukyu Bingata 琉球紅型 traditional garment with bingata dyeing
Sakizome 先染め pre-dyeing
Sakoku 鎖国 national isolation
Same 鮫 shark skin pattern
Seigaiha 青海波 blue ocean waves
Shi-no-ko-sho 士農工商 merchants
Shibori 絞り tie-dyeing
Shichi-Go-San 七五三
 seven-five-three ceremony
Shijuhaccha Hyakunezu 四十八茶百鼠 48 shades of brown and 100 shades of gray
Shinishozoku 死装束 burial kimono
Shippō 七宝 seven treasures
Shiromuku 白無垢 white wedding kimono
Sokutai 束帯 formal attire for imperial ceremonies
Surihaku 摺箔 metallic foil decoration
Takara-zukushi 宝尽くし treasure motif
Tanmono 反物 kimono fabric
Tatewaku 立涌 rising steam pattern
Tokugawa Ieyasu 徳川家康 ruler of Japan from 1603–1868
Tokyo Yuzen 東京友禅
 dyed kimono from Edo period
Tomesode 留袖 formal kimono for married women
Tonbo 蜻蛉 dragonfly
Tsukesage 付け下げ casual kimono
Tsumugi 紬 casual handwoven kimono
Tsuru-Kame 鶴亀 crane and tortoise
Uchikake 打掛 formal kimono
uramasari 裏勝り hidden splendour
Uroko 鱗 scales
Ushikubi tsumugi 牛首紬
 silk textile from Hakusan City
Yakusha monyo 役者文様 actor patterns
Yawarakamono やわらかもの dyed kimonos
Yotsumi 四つ身 child's kimono
Yuki tsumugi 結城紬
 silk fabric from Yuki City
Yukimochi 雪持ち snow-laden branches
Yukiwa 雪輪 snow wheel
Yumeji Takehisa 竹久夢二 Japanese poet and painter
Yuzen 友禅 hand painting and stencil dyeing
Zōri 草履 Japanese sandals

Lore of the Stars copyright © Quarto Publishing plc 2023
Illustrations copyright © Hannah Bess Ross 2023
Text copyright © Claire Cock-Starkey 2023

First published in 2023 by Wide Eyed Editions, an imprint of The Quarto Group.
1 Triptych Place, London, SE1 9SH, United Kingdom.
T +44 (0)20 7700 9000 **www.Quarto.com**

The right of Claire Cock-Starkey and Hannah Bess Ross to be identified as the author and illustrator of this work, respectively, has been asserted by them both in accordance with the Copyright, Designs and Patents Act, 1988 (United Kingdom).
All rights reserved.

No part of this publication may be reproduced, stored in a retrieval system or transmitted, in any form, or by any means, electrical, mechanical, photocopying, recording or otherwise without the prior written permission of the publisher or a licence permitting restricted copying.

ISBN 978-0-7112-8200-1
eISBN 978-0-7112-8202-5

Illustrated with coloured inks
Set in Budidaya and Slopes

Published by Debbie Foy
Designed by Belinda Webster
Design Assistance by Lyli Feng
Commissioned and edited by Alex Hithersay
Production by Dawn Cameron

Manufactured in Guangdong, China TT062023

1 3 5 7 9 8 6 4 2

LORE OF THE STARS

FOLKLORE & WISDOM FROM THE SKIES ABOVE

CLAIRE COCK-STARKEY
ILLUSTRATED BY HANNAH BESS ROSS

WIDE EYED EDITIONS

CONTENTS

THE SKY
WHY THE SKY IS SO FAR AWAY, a Nigerian tale	8
SKY DEITIES	10
RAINBOWS	12
AURORAS	14
WEATHER DEITIES	16
AUGURY AND AEROMANCY	18

THE SUN
PHAETHON DRIVES THE SUN CHARIOT, a Greek myth	20
CREATION STORIES OF THE SUN	22
SUN GODS AND GODDESSES	24
SUN LORE	26
SUNRISE AND SUNSET	28
ECLIPSES	30

THE MOON
WHY THE MOON WAS CREATED, an Indian Santal folktale	32
CREATION STORIES OF THE MOON	34
MOON DEITIES	36
MOON LORE	38
WAXING AND WANING	40
PICTURING THE MOON	42

THE STARS
HOW THE CONSTELLATIONS WERE FORMED, an Indigenous American tale — 44
CREATION STORIES OF THE STARS — 46
STARS LORE — 48
THE CONSTELLATIONS — 50
READING THE STARS — 52
THE ZODIAC — 54

PLANETS, COMETS AND SHOOTING STARS
THE MORNING STAR AND THE ORPHAN BOY, a Maasai tale — 56
LORE OF THE PLANETS — 58
GRECO-ROMAN GODS AND THE PLANETS — 60
VENUS, THE MORNING AND EVENING STAR — 62
COMETS, METEORS AND SHOOTING STARS — 64

THE COSMOS
HOW THE COSMOS CAME TO BE, a Visayan Philippine tale — 66
CREATION STORIES OF THE COSMOS — 68
MYTHS AND COSMOLOGY — 70
THE MILKY WAY — 72
BEYOND THE COSMOS — 74

GLOSSARY — 76
INDEX — 77

WHY THE SKY IS SO FAR AWAY

a Nigerian tale

Today the vast blue of the sky sits high over our heads, but many hundreds of years ago it was so close to the ground that anyone could just reach up and touch it. Back then, in King Oba's kingdom, the sky provided everything people needed. They didn't have to work the fields, fetch wood or spend hours toiling over a hot stove. Whenever anyone felt hungry, they could break off a chunk from the sky, which was delicious and many-flavoured. The sweetest corn, the richest stew or the fluffiest rice – each bite of the sky tasted of a different delight.

Since they never had to farm or cook, the people could devote many hours to creating art and music. They wove cloth, carved masks, composed songs and held many festivals. It was a peaceful and happy life.

But over time, the people stopped appreciating all they had. They became greedy, always taking more of the sky than they really needed. Piles of discarded sky started to heap up all over the land.

The sky became angry and grew dark with rage. Black clouds gathered over King Oba's palace and a voice boomed out: "King Oba! Tell your people to stop wasting my gifts!"

King Oba looked fearfully up at the sky and replied: "Please forgive us, sky! I will send messengers to every corner of my kingdom and from now on, no one will take more than they need."

The clouds dispersed and the sky became blue once again. The king kept to his word and the people listened to his decree. They focused on their art and music and ate only what they needed. King Oba decided to hold a big party to celebrate. Huge crowds gathered and people danced and sang. They were having such a great time that they forgot themselves and started greedily taking huge chunks of the sky to eat.

When the Sun rose in the morning and the party ended, everyone was so full they could eat no more. As they headed home, they threw uneaten pieces of sky onto the rubbish heap. The sky was furious and began to float away, higher and higher. King Oba fell to his knees as he watched it move far beyond his grasp. "Please, sky!" he cried. "We are sorry, come back! What are we to do for food?" The sky paused and angrily told the king that his people would have to learn to grow crops, hunt animals and cook food. "If you work hard," the sky called as it drifted ever higher, "you will never go hungry."

From that day on, the people spent all their time working the land to grow food. Every time they looked up at the great blue sky, they were reminded never to take the gifts of nature for granted.

SKY DEITIES

Around the world and throughout history, many cultures have believed that the sky is the home of the gods. The gods and goddesses of the sky often play a vital role in stories of the creation of the universe, and some are even said to rule over all other gods.

In ancient Mesopotamia, Anu was the sky god and chief of the gods. In Sumerian, his name means 'sky'. He was the father of all gods, demons and evil spirits.

Taranis was the Celtic sky god, who wielded a lightning bolt in one hand and a wheel, representing the Sun, in the other. The Thunderer, as he was known, caused the skies to rumble as he moved across the heavens.

Zeus, god of the sky, is the king of the gods in Greek mythology. From their home on Mount Olympus, Zeus keeps watch over all creation. When the Olympian gods overthrew the Titans, Zeus forced the Titans' leader, Atlas, to hold up the skies for all eternity.

Mother Hulda is a sky goddess from German lore who flies through the night leading an army of witches. She is an ancient, supreme goddess who was believed to control the weather. Even today, when it snows, it is said that Mother Hulda is making her bed.

In Indigenous American Haudenosaunee folklore, the Sky People are divine beings. In one legend, Sky Woman falls through a hole in the sky and lands just as the earth is formed. She gives birth to twin sons: one creates all that is good in the world and the other all that is bad.

In Polynesian mythology, Rangi, the sky god, lay in a tight embrace with the earth goddess Papa, his wife. Their children forced them apart to create space for the world to grow. Now Rangi is far away from Papa and misses her terribly. Every night his tears settle on the grass as morning dew.

RAINBOWS

Rainbows are caused by sunlight bouncing off droplets of rain in the sky. This creates a wondrous arc of many colours, and has inspired diverse traditional beliefs about the power of this natural phenomenon.

In Aboriginal Australian lore, the world was created by the great Rainbow Serpent. Each Aboriginal nation has its own version of the story. In Kunwinjku tradition, the Rainbow Serpent sucks up all the water on Earth during the dry season and spits it out as rain during the wet season.

In Greek mythology, the goddess Iris uses a rainbow as a pathway to bring messages from the gods to mortals. She is said to replenish rain clouds by using a rainbow to suck the water up from the sea.

The Bifröst in Norse mythology is a rainbow bridge between the earth and Asgard, the home of the gods. Heimdall, the watchman of the gods, guards the Bifröst. He can see for hundreds of miles and hear grass growing in distant meadows.

In Hindu mythology Indra, the god of thunder and rains, rides through the sky on his four-tusked white elephant Airavata. Indra uses the rainbow as a magical bow with which to shoot arrows made of lightning.

Prende is the goddess of love and beauty in Albanian lore. She was said to ride in a chariot pulled by swallows and she wore a belt made from a rainbow.

Anyone lucky enough to find the spot where a rainbow touches the earth is said to find a crock of fairy gold. In Irish-American tradition, the pot is guarded by a leprechaun, who may not be happy to share their treasure!

AURORAS

In the night sky above Earth's poles, solar particles collide with the atmosphere to create magical flashes of dancing light, called auroras. The aurora borealis, or northern lights, and their southern counterpart, the aurora australis, have inspired many myths and legends from the farthest reaches of the world.

The Sami people, who come from the far north of Europe, say that the northern lights are the shimmering torches of reindeer herders, searching the night sky for their herds.

The Saulteaux of Canada, and the Tlingit and Kwakiutl of the Pacific Northwest coast of North America, are peoples who share a belief that the northern lights are the spirits of the dead, dancing joyfully in the night sky.

In the Faroe Islands of the North Sea, folk wisdom warns children to keep their hats on during the winter, in case the northern lights burn off their hair!

In Estonia, the northern lights were said to appear when magical horse-drawn carriages travelled through the sky to take guests to a magnificent wedding feast in the heavens.

Auroras are rarely seen in China, so when the blazes of colour did appear in the sky, they inspired stories of good and evil dragons breathing fire at each other.

The Gunai people of eastern Australia saw the southern lights as bushfires raging through the lands of the spirits. The lights were seen as an omen of impending doom.

WEATHER DEITIES

Humans have always been at the mercy of weather – sun and rain bring life to crops, but storms and drought can destroy homes and livelihoods. It is no surprise that the gods and goddesses said to wield this mysterious power command both fear and respect throughout world mythology.

Perun was the Slavic thunder god who wore a crown made of lightning and rode through the sky on a millstone.

Raijin and Fujin are two of the most feared kami, or gods, in Japanese tradition. Raijin is the kami of thunder and lightning, who brings life-giving rain or violent storms depending on his mood. Fujin is kami of the winds. He stores all the air in a huge sack and lets it out to create blustering gales.

The Maya worshipped the god Chaac, who with his axe of lightning struck the clouds to make thunder and rains. Chaac resembled a human but was covered in scales like a reptile.

In Nigerian Yoruba mythology, Oya is a rain goddess. She has great power and can unleash storms, tornadoes, earthquakes and floods. Oya is patron of the mighty Niger River that spans West Africa.

Yu Shi is a rain god from Chinese mythology. With his demonic face and snakes writhing from his ears, he casts a frightening figure – but in one story he ended a terrible drought by sprinkling rain from his earthenware jug.

Mariamman is a Hindu goddess of rain. In southern India a festival occurs each April during which people wear yellow, her favourite colour, and perform traditional folk dances to gain her favour and ensure plenty of rain for the crops.

AUGURY AND AEROMANCY

Believing the sky to be the home of the gods, ancient people often looked to the heavens for signs of things to come. Only those with special gifts, such as shamans or priests, were thought to be able to understand and interpret the messages in the sky.

Aeromancy is predicting the future by observing clouds, winds, thunder or lightning. In ancient Babylon, Adad, the god of thunder, was believed to bring messages to his followers through the rumble of his thunder.

In ancient Rome, it was believed that the future could be read in the flight of birds. This was called augury and was carried out by priests known as augurs. They would ask a question, then watch the direction of a bird's flight to get their answer. A bird flying straight towards you was a sign that happiness lay ahead.

In Dodona, the ancient Greeks created a special grove of oak trees dedicated to Zeus. Here priests would listen to the sound of the wind rustling through the leaves of the trees to divine the future.

In England, it was thought that crows flying home to roost would make letters in their flight, and that if you put the letters together, you might find a message.

American farmers traditionally observed signs from nature to predict the weather. Bees coming out of their hives and flying around during February was a sign that the following day would be windy and rainy, while the sound of thunder in March meant the year's harvest would be good.

In medieval Ireland, priests called druids used to watch the shape, colour and movements of the clouds in order to predict the future. This practice was known as 'néladóracht'.

PHAETHON DRIVES THE SUN CHARIOT

a Greek myth

All his life, Phaethon was sure he was destined for great things. After all, his mother, the sea nymph Clymene, had blessed him with a name that meant 'shining one'. As Phaethon grew older, he began to wonder why he only had a mother and so he decided to ask her where his father was.

"Please mother, tell me his name, so that I can meet him," Phaethon begged. Clymene looked at her beautiful son, with his flaming golden hair, and realised she could keep the secret no longer. "Your father is Helios, the Sun God," she replied with a sigh. "He must drive his Sun Chariot through the sky every day, and that is why he cannot live with us."

"I knew it!" Phaethon cried, "I am no ordinary mortal!" From that day on, all Phaethon could think about was meeting his father. One morning, while gazing at the rising Sun, he decided to sneak away and search for him. After months of travel Phaethon at last arrived at Helios's magnificent golden palace, far in the east. Barely daring to breathe, Phaethon stepped into the palace and saw Helios for the first time, sitting on a diamond-studded throne.

Phaethon humbly explained who he was, then dropped to his knees and begged Helios to recognise him as his son. Touched by his words, Helios placed a kindly hand on the boy's head and vowed to prove his love by granting him any wish he desired. His head spinning with joy, Phaethon asked for his dearest wish: to be allowed to drive the Sun Chariot through the sky for one day. The room fell silent and dark as Helios frowned. "Even the great Zeus, king of the gods, cannot control my chariot, dear boy. Choose another wish." But Phaethon would not be dissuaded – and when a god agrees to grant a wish, he cannot take it back.

Phaethon was so proud to be at the helm of the golden chariot, pulled by fierce horses that blazed with light. But despite his arrogance, he was just a mortal and, with growing horror, he realised that he could not keep the chariot on the right path. The fiery horses began to buck and rear, causing the chariot to plunge towards the earth. Its heat scorched Africa, turning huge swathes of the land into desert. Phaethon hurtled on, unable to stop the Sun from burning the earth.

Helios cried out to Zeus for help, desperate to avert disaster. Zeus took the only action he could. He struck Phaethon with his thunderbolt, and the boy fell from the chariot and plunged into a river below, lost forever. Helios took control of his chariot and steered it safely west, vowing never to let another take the helm. Clymene wept bitter tears at the loss of her foolhardy son, wishing she had never told him the truth.

CREATION STORIES OF THE SUN

The Sun is Earth's closest star, and without its warmth and light, life would not be possible. In creation stories from around the world, the origin of the Sun is often one of the most important moments.

In a legend from the Tsimshian people of North America, the world used to be pitch black. All the light was kept in a box by an old man. One day, Raven tricked the old man into opening the box, then grabbed the light and flew into the sky, creating the Sun and bringing light to the world.

The great creator god of the West African Fulani people is called Gueno. He created the Sun by plucking out one of his eyes and placing it in the sky. Before the Sun existed, the mountains were as soft as butter, but Gueno's eye shone down with such intensity that it made the mountains solid.

In some Hindu beliefs, the earth was formed from a giant egg that split in half, making the mountains, sky, rivers and oceans. The god Vishnu emerged and made the first sound in the universe: "Om". From this wonderful sound Surya, the Sun, was created.

In Ancient Egypt it was said that the great solar creator god, Atum, formed themselves from the primordial waters called Nu. Atum was both male and female so they could create all the rest of the gods by themselves.

In Norse mythology, the Sun was said to have been formed by the gods from a spark of fire. It was placed in a chariot that was drawn by two white horses and driven by Sol, the Sun maiden. The gods protected the earth from the burning heat of the Sun by placing a special shield known as Svalinn in front of the chariot.

SUN GODS AND GODDESSES

Many cultures see the Sun as an all-powerful god or goddess. These Sun deities are often clothed in gold, bringing light and warmth wherever they go.

Helios is the Greek Sun god. In art he is often shown as a handsome young man with glowing eyes and a crown of flames. Just like the Sun's rays that spread across all the world, Helios was said to see and know everything.

The Baltic Sun goddess is called Saulė. She wears clothes and shoes of gold and pours sunlight from a large jug onto the world below.

In Irish mythology Lugh is a Sun god, great hero and leader of the gods. Lugh has a special lightning spear known as Gáe Assail, which always hits its target. The spear is so bloodthirsty it has to be kept in a bucket of icy water or it will try and start a fight on its own!

Amaterasu is the Japanese Sun goddess. One day, she hid in a cave because her brother, the storm god Susanoo, was causing chaos. With Amaterasu gone, all the light from heaven and earth disappeared. To tempt her out, the other gods threw a party with singing and dancing. Amaterasu soon emerged, flooding heaven and earth with precious light once more.

For the Navajo of North America, Tsohanoai is the god who carries the Sun across the sky on his back each day. At the end of the day, Tsohanoai hangs the Sun on a peg in his house while he rests.

Freyr is the Norse god of summer sun, harvests and fertility. He rides on Gullinborsti, his golden boar. No matter how dark it gets, the glow from Gullinborsti's bristles always brings light.

SUN LORE

As the brightest object in the sky, the Sun is often associated with power and wisdom. Its golden rays are seen as a blessing and warm, cloudless sunny days are cause for celebration around the world.

In the northern hemisphere, summer solstice is the longest day of the year and falls between 21st and 22nd June. Many ancient stone circles, such as Stonehenge, were built so that the first rays of the Sun on the solstice can be seen by anyone standing at their centre.

A superstition from Mexico warns against sleeping with your head pointing towards the rising Sun. Anyone sleeping in this position was said to wake up with a terrible headache.

Midsummer is celebrated around the summer solstice. In Germany, hunters would traditionally shoot arrows at the Sun on this day. They believed that this ensured they'd never miss their prey in the coming year.

Across northern Europe, huge bonfires were traditionally lit on Midsummer's Eve to represent the Sun. They were believed to bring plentiful crops and good luck for the year ahead.

The ancient Egyptians believed that gold-coloured topaz got its colour by absorbing the Sun's rays. Anyone who wore topaz was thought to become braver and wiser.

In the Netherlands it's said that if the Sun shines while it's raining, then witches are baking cakes.

SUNRISE AND SUNSET

The daily journey of the Sun as it rises in the east, sails up and across the sky and then sets in the west, has inspired a number of myths and legends from cultures across the world.

Eos is the Greek goddess of the dawn, and each day she rises early to announce the coming of the Sun. She is said to have rose-coloured fingers, like early morning clouds, and beautiful white wings. She carries a jug with which she sprinkles morning dew on the earth.

The Egyptian Sun god Ra sails across the sky each night in his boat and then heads back east through the underworld, in order to rise again each morning.

In Norse mythology Sköll is an enormous wolf who every day pursues the Sun across the sky, causing it to rise and set. Before Ragnarök (the end of the world) it was said that Sköll would catch and swallow the Sun. But before he entirely devoured it, a tiny portion would break off and form a new sun for a new world.

The Hesperides are Greek nymphs of dusk. One of their jobs is to guard the tree of magical apples in Hera's garden. The beautiful colours of sunset are caused by the golden glow of the fruit.

In some Aboriginal Australian beliefs, the Sun is a woman who every day wakes up in her camp in the east and prepares a bark torch to carry across the sky. Before she leaves, she paints herself with red ochre, usually spilling some, which turns the clouds red. At nightfall she travels underground back to her camp. As she walks, her torch warms the earth, causing the plants to grow.

ECLIPSES

A solar eclipse is a rare event when the Moon passes between Earth and the Sun, covering up our view of the Sun. Eclipses can be partial, when only a small part of the Sun is covered, or total, when the entire Sun is momentarily covered. The dramatic impact of an eclipse has led to some wonderful folkloric explanations.

One belief from the Batammariba people of West Africa is that eclipses occur when the Sun and Moon quarrel. Traditionally, people would gather outside in friendship, in the hope that the Sun and Moon would see the peaceful scene and calm down.

An evil serpent named Apep constantly chased the Sun god, Ra, through the sky in Egyptian mythology. Eclipses were said to happen when Apep managed to catch him. The other gods and goddesses would cut a hole in Apep's belly and release Ra to shine in the sky once again.

In Hindu mythology, Rahu is a demon who tried to drink the god's nectar of immortality. The gods cut off his head and it now flies through the sky in pursuit of the Sun. Every now and then Rahu catches the Sun and swallows it, causing an eclipse. But as the demon has no body, the Sun soon reappears.

In Chinese lore, eclipses are caused by a dragon eating the Sun or Moon. To scare away the dragon during an eclipse, people would go out into the streets and bang pots and pans together until it became light again.

In many Indigenous American cultures, such as the Choctaw, Cree and Menominee, an eclipse happens when a little boy captures the Sun in his net in revenge for getting sunburnt. The eclipse only ends when a mouse nibbles through the net and releases the Sun.

WHY THE MOON WAS CREATED

an Indian Santal folktale

When the world was first created and the Sun blazed brightly in the sky, the people were very busy. They constantly toiled in the fields, sowing seeds, weeding, watering and harvesting crops. It was hard work!

Marang Buru, the Creator, came down to see his handiwork and nodded in approval at how industrious the people were. "When did you plant those seeds?" he asked a farmer. "Today," came the reply.
"And when did you build that house?" he asked an elderly lady.
"Today, of course," she replied.
"When was that child born?"
"Today," said the child's father. Marang Buru looked at the child's older brothers and sisters and said, "But what about those children, when were they born?"
"Also today," their father said.

Marang Buru realised he had made a mistake. The people had no idea of time because the Sun always blazed in the sky. For them, every day was today! To solve this, he decided to tell the Sun to rest for twelve hours in every twenty-four.

That night, for the first time ever, the Sun set and it became pitch black. The people were terrified and began running this way and that, bumping into each other and falling into holes. When the Sun rose the next morning, everyone was battered and bruised.

"Whoops!" thought Marang Buru, "This won't do." He called everyone to a meeting. "Tonight," he announced, "when it gets dark, don't be afraid. Instead, take the chance to lie down and sleep."

That night, when the Sun went down, everyone had a glorious sleep. They awoke refreshed and happy. Now they could work hard all day but each night they could rest and recharge.

But there was still a problem. Night was pitch black and, when they weren't asleep, the people still bumped into things and hurt themselves. Marang Buru pondered the problem and at last he had a wonderful idea: he would create a cooler, dimmer version of the Sun!

The Creator placed the silvery Moon into the sky. It shone softly, casting a beautiful pale glow. Now the people could see where they were going but the light was not so bright as to keep them awake. From that day on, the soothing light of the Moon reminded the people to stop work and take a well-deserved rest.

CREATION STORIES OF THE MOON

Stories of the Moon are often closely tied to those of the Sun. Many cultures see them as siblings or husband and wife. The cool, pale Moon in the dark night sky is contrasted with the bright, fiery Sun of the daytime.

To the Aztecs, the Moon was the head of the goddess Coyolxauhqui. A myth tells that Coyolxauhqui tried to prevent the birth of her brother, Huitzilopochtli, who punished her by throwing her head into the sky.

The Abaluyia people of Kenya tell that the Sun and Moon were brothers created by the supreme god, Wele. They constantly fought and one day, Sun threw Moon down into the mud, dimming his glow. To stop the fighting, Wele decreed that Sun would rise in the day and Moon at night.

The San people of Southern Africa believe that their trickster god, Kaggen, once wanted to soften his sandal, so he placed it in a puddle. This annoyed a water sprite, who froze the puddle into a block of ice. Kaggen angrily threw the icy sandal into the sky, where it became the Moon.

In Korean folklore, a tiger once chased a brother and sister up a tree. They prayed for help and a metal chain appeared. They climbed the chain into the sky, where the boy became the Sun and the girl the Moon. But the girl was afraid of the dark, so they switched roles, and today the boy shines in the sky as the Moon.

In Filipino tradition, the Sun and Moon were once married, but one day they had a huge fight and Sun threw vegetables in Moon's face! Moon left Sun for good and went to rest in the night sky. When the Moon is full, you can still see the marks made by the vegetables on Moon's face.

MOON DEITIES

Moon gods and goddesses are often contrasted to their fiery counterparts, Sun deities. As such they are usually said to be cool, calm and serene, with a mysterious influence over the world.

In the lore of the Fon people from West Africa, the Moon and the Sun are twins who created the world. The Sun, Lisa, is associated with heat, strength and war. The Moon, Mawu, is linked with motherhood, night and rest.

The falcon-headed ancient Egyptian Moon god, Khonsu, was known as 'the traveller' because the Moon moves across the sky. He was believed to protect those who travelled at night.

Tsukuyomi is a Moon god in Japanese mythology. In some tales he was once married to the Sun goddess Amaterasu, but she left him after he killed another goddess. He is always chasing the Sun across the sky, desperate to win her back.

Hina was known to make the finest Kapa cloth in all Hawai'i, but it was in such high demand that she became exhausted. She fled to the sky but found the Sun too hot, and so she made her home on the cool Moon. Today Hawaiians call the Moon Mahina, in honour of the goddess.

Alignak is the god of the Moon in Inuit tradition. He controls the weather and the tides. Alignak is a protector of fishermen and sometimes shields them from the waves sent by the sea goddess, Sedna.

MOON LORE

During a lunar month, the shape of the Moon appears to change as the Sun lights up different portions. It goes through 'phases', from new, when the Moon is not visible, to full, when it is a bright, shining disc. The new and full Moon have inspired many folkloric beliefs over the centuries.

In New England, US, they say that if you get your hair cut during the new Moon it will look better than if you cut it during any other time of the month. But your hair will grow back more quickly, since anything started during the new Moon thrives.

In British and Irish tradition, a new Moon should always be greeted with a polite bow. This ensures the Moon's good favour in the coming month.

A Moon festival is held in mid-autumn in Chinese culture, because the autumn full Moon is thought to be the brightest. Families gather together, holding lanterns to signify the light of the Moon, and share pastries called mooncakes.

Traditional farming folklore says that plants that bloom above the ground, such as corn or lettuce, should be planted during the first phase of the Moon.

From the second quarter to the full Moon, ground crops such as watermelons and squash should be planted.

The week after full Moon, it's time to plant below-ground plants such as carrots and potatoes.

The word 'lunacy', meaning madness, comes from the Roman Moon goddess Luna. A full Moon was associated with unstable behaviour and it was said that those who stared at the Moon for too long could lose their sanity.

According to Hindu mythology, the gem moonstone is formed from moonbeams. It's said that if you place a moonstone in your mouth during a full Moon you will be able to see into the future.

WAXING AND WANING

Between the new and full phases, the Moon appears to wax (grow) and wane (decrease). During these phases it looks like a half-circle or crescent in the sky. Myths and legends from around the world have explained why the Moon's shape changes over a lunar month.

In Egyptian mythology, the sky god Horus formed the Sun from his right eye and the Moon from his left eye. But the left eye was damaged when he set it in the sky, which is why it waxes and wanes.

Alklha is a huge black dragon from Siberian Buryat mythology whose body and wings fill the night sky with darkness. The Moon becomes smaller each month as Alklha nibbles on it at night. But this gives him tummy ache, so he vomits up little pieces of the Moon until it's full again!

According to folklore of the Inuit of Greenland, the Moon, Anningan, is so busy chasing his sister Malina, the Sun, that he forgets to eat, and so gets thinner as the days go by. Every month, Anningan disappears for three days while he finally eats. He then returns, full and round, to chase his sister once again.

In a belief from the San people of the Kalahari, the Moon is a man who angered the Sun. Each month he gets fatter, but once he is full, the angry Sun cuts pieces of him away until there is only a tiny bit left, from which he grows anew.

Hindu legend tells that one night, the god Ganesha stumbled and dropped armfuls of his favourite sweets on the floor. The Moon laughed at him, which made Ganesha so angry that he cursed the Moon to disappear forever! Shiva, the most powerful god, realised this would cause chaos and begged Ganesha to be merciful. Ganesha agreed that the Moon would only gradually disappear.

PICTURING THE MOON

Unlike the Sun, which is dangerous to stare at, the full Moon's silvery glow invites your gaze. The shadows and craters make a variety of interesting shapes on the Moon's surface, and have led to many folktales that imagine who, or what, might live there.

Many Asian cultures see a rabbit on the Moon bending over a pestle and mortar. In China it's said the rabbit works for the Moon goddess Chang'e, creating the elixir of life.

In Jewish tradition, the Man in the Moon was banished there for collecting sticks on the Sabbath, the day of rest.

A Salish tale from North America tells that Wolf fell in love with Toad and asked Moon to shine brightly, to reveal where Toad lived. Toad did not want to marry Wolf so she asked Moon why it was helping him. When Moon replied that it helped everyone, Toad sprang into the air and landed on Moon's surface, so she could live alone.

Peruvian folklore tells that Fox and his friend Mole were desperate to visit the Moon, so they wove a strong rope from pampas grass and asked Owl to lasso it over the Moon. Fox climbed all the way up and made his home there, but Mole quickly grew tired and decided he preferred life beneath the earth.

When the Aztec gods were making the cosmos, they asked for two volunteers to become the celestial orbs. Nanahuatzin and Tecciztecatl jumped into a magical fire and transformed into two blazing suns. But the gods realised they did not need two suns, so they threw a rabbit at Tecciztecatl to dim his glow, and he became the Moon.

HOW THE CONSTELLATIONS WERE FORMED

an Indigenous American tale

Long ago, when the Sun shone brightly in the sky, the people went out and worked in the fields, hunted for food and collected wood for the fire. But each night, the world became shrouded in darkness with only the eerie glow of the Moon for light, and the people were afraid.

A meeting was called and the people gathered in the early morning light. They decided to ask the Great Creator for help. Wise and patient Creator listened to their worries and realised he needed to make the night beautiful and reassuring.

"Children," he said (for all the people on earth were children to him). "Go down to the river and collect as many bright, shiny pebbles as you can and bring them here."

The people immediately did as he asked and soon returned with a huge sack of stones from the riverbed.

"Now," he continued. "I want you to take the rest of this sack and use the pebbles to draw pictures of yourselves in the sky."

The people excitedly began forming the shapes of animals and people, but it was heavy work and they soon tired. The Great Creator took pity on them. After all, they had been working hard in the fields all day. Instead he asked Coyote, who had spent all day snoozing under a bush, to complete the task.

Coyote was thrilled to be given such an important job, but he wasn't very patient. Instead of carefully placing each pebble, he grabbed the sack and threw its contents slapdash across the sky. This is why there are so many stars strewn across the sky and why not all the pictures in the sky are quite finished.

Coyote realised too late that he had forgotten to make a picture of himself – and the sack was now empty. In his despair he threw back his head and howled. From that night on, Coyote howls every time he looks up at the night sky and sees it illuminated with the twinkling stars, in the shapes of all the people and animals except him.

CREATION STORIES OF THE STARS

Today we understand that stars, like our own Sun, are huge balls of blazing gas. But ancient peoples had a different understanding of the night sky, with myths and legends to explain the distant, twinkling lights.

In a tale told by the Tsimshian of North America, the Sun is a boy wearing a flaming mask, who crosses the sky each day. At night, he sleeps below the horizon, and his snores send up sparks that form the stars.

The ancient Greeks imagined the heavens as a huge dome made from bronze onto which the constellations were fixed. The Titan Atlas was responsible for spinning the dome on his shoulders, causing the stars to rise and set.

A folktale from South Africa tells that a little girl with magical powers once looked at a pride of fierce lions. They were immediately turned to stone and became the stars in the sky.

Rolla-Mano is the old man of the sea in Aboriginal Australian mythology. One day, two women encountered him in a swamp, and he tried to capture them. One of the women escaped by diving into the water. Rolla-Mano jumped in after her, but forgot he held a fire stick. As it touched the water, it threw up sparks that settled in the sky as stars.

In Babylon it was believed that the stars were created by the gods who drew pictures of animals in the heavens. Early astronomers saw the stars as messages written in the night sky.

In Norse mythology the universe was created from the body of the giant Ymir. His skull formed the dome of the sky and sparks from Muspelheim, the realm of fire, created the stars.

STARS LORE

Spotting the first star shining in a night sky always feels magical, partly because on a cloudy night there might not be any stars visible at all. The wonder sparked by seeing stars has led to many fascinating superstitions and beliefs.

It's a common belief that you can make a wish when you see the first star in the night sky. To ensure the wish comes true, some people chant,

'Star light, star bright,
first star I see tonight;
I wish I may, I wish I might,
have the wish I wish tonight.'

In Bulgarian tradition, each person has a star connected to them. If a child is often ill they are said to have a weak star, but if they are successful in all they do, they are called a bright star.

In Chile, people pick up a pebble for good luck when they see the first star, and in the Philippines, they tie a knot in their handkerchief.

Traditional Irish weather lore says that if the stars twinkle in the night sky then a frost is expected the next day.

The Brisingamen was a beautiful, many-jewelled necklace fashioned by the dwarves of Norse mythology and worn by the goddess Freya. The lovely necklace came to represent the stars and its lustre enhanced Freya's great beauty.

The stars that rise in July are especially sacred among some Buddhist communities, because they are associated with the time of year that Buddha became enlightened. In parts of Asia, people leave buckets of water outside to absorb the starlight, and then bathe in the holy water.

THE CONSTELLATIONS

Since ancient times, people have looked up to the night sky and seen patterns and pictures in the stars. These groups of stars are known as constellations. Different constellations are visible from different parts of Earth.

The Western Mono people of California, US, tell that a group of women were walking together one day and found some wild onions. They happily ate the onions, but their husbands complained it gave them 'skunk breath' and threw them out of the village! The women flew into the sky and became the constellation Pleiades, leaving the men sad, sorry and lonely.

In Greek myth, Orion was a great hunter who was killed when he stepped on Scorpius, the scorpion. The gods felt sorry for Orion, so they placed him in the sky as a constellation, with his dogs Canis Major and Canis Minor as companions.

The constellation Ursa Major (also known as the Great Bear) was thought by the Sumerians to be a huge wagon driving across the night sky.

In Aboriginal Australian lore, Mululu wished to never be parted from his four beloved daughters. When he died, he became a star and plaited his long beard so that his daughters could climb up and join him in the sky. Today, they all twinkle together as the Southern Cross.

The Lummi people of North America say that Coyote liked to impress people by juggling with his eyeballs. One day, he threw his eye too high and it got stuck in the sky, becoming Arcturus, one of the brightest stars in the northern sky.

Berenice II, a queen of Egypt, cut off her hair and placed the locks in a temple as thanks for the safe return of her husband, Pharaoh Ptolemy III, from war. The hair disappeared and was said to have become the constellation Coma Berenices ('Berenice's hair').

READING THE STARS

Some stars shine especially brightly at certain times of the year, some rise and set like the Sun, and others barely move at all. The night sky, therefore, can be used for many purposes, including as a calendar, for navigation or even to predict the future.

Sailors traditionally used stars like a map to find their way back home. In Greek myth, the twins Castor and Pollux, who became stars in the Gemini constellation, protected sailors from storms.

Polaris, the North Star, hangs directly over the North Pole and many cultures have long used it for navigation. In Mongolian tradition, the North Star is believed to be a peg that holds the whole world together.

In Southern Africa, the Pleiades are known as 'IsiLimela' or the 'digging stars'. This is because their first appearance in the sky each year marked the start of the growing season, when farmers must begin hoeing the ground.

Every year in the middle of August, Sirius is the first bright star to appear in the night sky over Egypt. Its appearance coincides with the flooding of the river Nile, so ancient Egyptians living on the banks of the river used it as a signal to move inland to safety.

The Maya were excellent astronomers and used their observations to create advanced calendars. They knew Polaris as Xaman Ek, after their god of merchants. They looked to Xaman Ek for guidance and direction.

Aboriginal Australians may have been the world's first astronomers. Traditional Aboriginal astronomy sometimes takes the space between stars as shapes, rather than the outlines the stars make. The Emu in the Sky is one example, where dark nebulae (clouds of dust and gas in outer space) form the texture of the bird's feathers.

THE ZODIAC

Astrology is the ancient art of using the positions of the stars and planets to make predictions about human affairs. The Zodiac is a large belt across the sky that the Sun, Moon and planets all move through in the course of a year.

In Western astrology, the Zodiac is divided into twelve sections that each relate to a traditional Greek constellation. Astrologers use the position of the Sun, Moon and planets at the moment of a person's birth to predict their character.

The Chinese Zodiac was said to have been created by the Jade Emperor. He asked all the animals to compete in a race: the first twelve to cross the finish line would have a house of the Zodiac named after them. These were Rat, Ox, Tiger, Rabbit, Dragon, Snake, Horse, Goat, Monkey, Rooster, Dog and Pig.

Medieval Islamic astrologers adopted the Greek signs of the Zodiac. Items decorated with pictures of characters from the Zodiac were believed to act as lucky charms, protecting the owner from any bad planetary influences.

ARIES

TAURUS

GEMINI

CANCER

LEO

VIRGO

Mayan astrology was based on their 260-day sacred calendar. There are 20 days in each Mayan month and each day has its own sign, such as crocodile, wind or grass. These signs were used to predict a person's personality depending on the time and location of their birth.

The four most important stars in Persian astrology were the 'Royal Stars': Aldebaran, Regulus, Antares and Formalhaut. Each represented one of the directions of the compass. Good fortune was believed to follow when they were favourably aligned and bad fortune when they were not.

THE MORNING STAR AND THE ORPHAN BOY

a Maasai tale

Lemayian had led a long and difficult life, herding his cattle and working the land. His name meant 'blessed one', but he didn't feel very blessed – he felt old, tired and lonely.

One night, Lemayian headed out to fetch his cattle home for milking. Suddenly, he stopped in surprise and stared at the sky: one of the brightest stars was missing! How strange... Lemayian was so engrossed in his thoughts that he nearly bumped into a small boy.

"Child!" he exclaimed, "What are you doing out in the bush at night, all alone?"

"I have travelled many miles, sir," the boy said solemnly. "My name is Kileken. I am an orphan searching for a home." Lemayian was taken aback by this turn of events, but he offered the boy a home. Kileken beamed with joy and promised to be a great help.

The boy was as good as his word. When Lemayian woke in the morning he found all his chores had been done and a hot bowl of porridge was waiting for him. "You rest there," said Kileken, "I will take the cows to pasture."

Kileken was out with the cows all day and only returned at sunset. Lemayian marvelled at his energy and asked how he managed to get so much done.

"I get my energy from the first light of day," Kileken replied, and took himself happily to bed.

As the days and weeks passed, Kileken took care of all the chores, and Lemayian's homestead flourished. Not only this, but at last the old man had a companion. He was so happy, but questions nagged at his brain. Where had this strange child come from? And how was he so full of energy? Whenever Lemayian tried to question the boy, Kileken would say, "I can't tell you my secret and you mustn't ask, because the day our trust is broken is the day your good luck will end."

As spring turned to summer, the land was gripped with a terrible drought. Lemayian worried that his cattle would die, but every day Kileken brought them back from pasture with full bellies.

The old man couldn't contain his curiosity any longer and he decided to follow Kileken. Lemayian watched in surprise as the boy scaled a huge rock. He stood on top of it with his arms stretched up to the heavens, and as the Sun rose a ray of light hit Kileken and radiated outwards. As the light spread over the parched ground, it became covered with lush, green grass.

But then Kileken saw the old man. His heart broke as he realised the bond of trust had been severed. Kileken disappeared in a blaze of light. Lemayian never saw the boy again, but a new star appeared in the night sky. The Maasai of Kenya and Tanzania call this star Kileken, the orphan boy. It arrives at first light to lead the cattle out to pasture and returns in the evening to lead them home for milking.

LORE OF THE PLANETS

The planets were once known as 'wandering stars', as they appear to move across the sky and to the naked eye they look like stars. Mercury, Venus, Mars, Jupiter and Saturn are all visible without a telescope, and so were familiar to ancient astronomers.

In Egyptian mythology, the falcon-headed god Horus was associated with the planets Saturn, Jupiter and Mars. Venus was linked to Horus's father, Osiris, the god of order, and Mercury to Osiris's brother, Seth, the god of disorder.

The planets visible to the naked eye were all given female names in Baltic tradition. It was believed that the planets were all daughters of the Sun goddess, Saulė, and the Moon god, Mėnulis.

In Hindu mythology, Mars is Mangala, the god of anger. He has four arms and rides a ram, and like the planet, he is red in colour. Some say Mangala was created after his mother, the earth goddess Bhumi, dropped some red coral into the ocean.

For the ancient Babylonians, each planet was linked to a god. Mercury was associated with Nabu, the god of wisdom; Saturn was coupled with Ninurta, the god of healing; Mars with Nergal, the god of death; and Jupiter with Marduk, the patron of the city of Babylon.

Medieval Islamic astrologers believed in the existence of an invisible planet. It was known as al-tinnin, 'the dragon', and it was thought to be responsible for eclipses.

The Aztec serpent god Quetzalcoatl was believed to have been reincarnated as the planet Venus. The planet was therefore associated with death and renewal.

GRECO-ROMAN GODS AND THE PLANETS

Ancient Roman astronomers named the five planets that can be observed from Earth without the aid of a telescope, and we still use these names today. They called the planets after their gods, who under different names were also the gods of Greek mythology.

Venus is named after the Roman goddess of love, known as Aphrodite to the Greeks. Other than the Sun and Moon, the planet Venus is the brightest object in the night sky and so it was likened to this goddess of love and beauty.

Mercury appears to move fast across the sky, orbiting the Sun in just 88 days. The god Mercury (Hermes in Greek mythology) was the patron of travellers, merchants and tricksters.

Cronus was a Greek god of agriculture. The Romans named the planet Saturn after their equivalent god. In mythology, Saturn is the father of Jupiter and the two powerful gods fought for power. Jupiter ultimately beat Saturn and was crowned king of the gods.

Jupiter is the largest visible planet, so it makes sense that it was named after the king of the Roman gods, whom the Greeks called Zeus.

Owing to its blood-red colour, the planet Mars was named after the god of war, whom the Greeks knew as Ares. Mars was the second-most important Roman god and the protector of Rome.

After the invention of the telescope, three planets in our solar system were discovered and named after gods: Uranus, Cronus's father, was a Greek god of the sky; Neptune was named after the Roman god of the sea, because of its blue colour; and Pluto (which is no longer classed as a planet) was named after the Roman god of the underworld, because it is so far from the Sun.

VENUS, THE MORNING AND EVENING STAR

Of all the planets, Venus has arguably fascinated people the most over the centuries. This is because it's one of the brightest objects in the night sky. In the past, Venus was thought to be two different planets, which the ancient Greeks called Eosphorus, the morning star, and Hesperus, the evening star.

In the Fens of East Anglia, England, it was thought lucky for a baby to be born as the light from Venus was shining in through a window.

The Maya knew Venus as Kukulkan, after the feathered serpent god of the same name, and the planet was associated with warfare. The position of Venus in the sky was carefully tracked and Mayan astronomers used it to decide when to go into battle.

According to the Skidi Pawnee people of the midwestern US, the Morning Star, the Sun and all the male stars and planets wanted to create the world, but the Evening Star, the Moon and all the female stars and planets did not. The Morning Star wooed the Evening Star and won her heart, and so it was that the world was created.

In Bulgarian folklore, the Morning Star is known as Zornitsa and the Evening Star as Vechernitsa. They are said to be the sisters of the Sun and Moon. The Sun likes Zornitsa best because she shines early in the morning, whereas the Moon prefers Vechernitsa, who glows in the evening.

The ancient Sumerians associated the planet Venus with the goddess Inanna, Queen of Heaven. She was considered a goddess of war and was often depicted wearing armour and carrying weapons. To represent her courage, she was also said to ride a lion.

COMETS, METEORS AND SHOOTING STARS

It's rare to see a shooting star and the sudden flare of light in the dark sky can seem quite dramatic. The sight of a star, comet or meteor blazing through the sky is often thought to be an omen – for good or ill.

In Romanian tradition, every star in the sky is thought to be like a candle that represents a person alive on Earth. When a shooting star is seen, it's said to be someone's 'candle' extinguishing and falling from the heavens, so shooting stars are taken as a sign of death.

The largest meteorite ever found in the US is called the Willamette. It is sacred to the Clackamas people of Oregon, who call it Tomanowos, meaning 'visitor from heaven'. To bestow good luck before battle, warriors would wash their faces in the rainwater that collected in its craters.

In Estonia, it was said that meteors were hot stones thrown from the heavens by cranky old demons.

In Yorkshire, England, a shooting star traditionally signalled a birth. Stars were thought to be the souls of babies falling from the heavens, ready to begin a new life.

Traditional lore from the New England region of the US says that when you spot a shooting star, you must say,

'Money before the week's out!'

three times before it disappears from sight. This will ensure good fortune.

When a shooting star is spotted in Mongolia, people spit on the ground and say,

'It's not mine.'

This is because each star is believed to be the energy of one living person and a shooting star represents the end of that energy and the end of their life.

65

HOW THE COSMOS CAME TO BE

a Visayan Philippine tale

At the beginning of time there was no Sun, no Moon, no stars and no land; there was only a vast ocean and an endless sky. The ocean belonged to the goddess Maguayan, and the sky was the kingdom of the god Captan.

Maguayan had a daughter named Lidagat, and she was the sea. Captan had a son named Lihangin, and he was the wind. Over time, Lidagat and Lihangin fell in love, and together they had four lovely children, three sons and one daughter: Licalibutan's body was made of rock and he was strong and brave; the always happy Liadlao was made of gold; Libulan was made of copper and he was quiet and timid; and Lisuga was silver and she was beautiful and kind.

Time passed, and Lidagat and Lihangin grew old and died. The children grieved for their parents, missing their wise counsel. Without the guidance of his father and mother, Licalibutan became restless. The force of the wind blew through his soul and he decided to demand more power from his grandfather, Captan. He told his brother Liadlao of his plan. At first, kind Liadlao was shocked, but he couldn't bear to upset his brother, so he agreed to help. Together they persuaded shy Libulan to join, too.

The three brothers flew to the great steel gates of Captan's realm and Licalibutan summoned all the power of the wind to blow them apart. "Who dares to desecrate my realm?" Captan boomed as he emerged through his broken gates in a great fury.

The sight of their grandfather glowering with rage sent the brothers running for their lives, but it was too late! Three lightning bolts issued from Captan's eyes, the first hitting copper Libulan and the second golden Liadlao, melting them into balls. The third bolt smashed into rocky Licalibutan and broke him into many pieces. These fell into the ocean, becoming land.

Lisuga sensed that something was wrong and went to search for her brothers. When she arrived at Captan's broken gates he was still in a blind rage. Without thinking, he loosed off another lightning bolt that shattered her silver body into millions of pieces.

When Maguayan saw what had happened, she was stricken with grief. Captan had calmed down and he was filled with remorse. They decided that although they could not bring their beloved grandchildren back to life, they could gift them a beautiful shining light.

And so it was that copper Libulan became the Moon, golden Liadlao was made the Sun and the shards of silvery Lisuga glistened in the sky as the stars.

But Captan and Maguayan could not forgive Licalibutan, and they did not give him any light. Instead, they deemed that his body should support new life, so they planted a seed on the land and from that seed, bamboo grew. Out of the plant's hollow stems stepped the first man and the first woman, from whom all humans descend.

CREATION STORIES OF THE COSMOS

The cosmos is another way to describe the entire universe. Early astronomers used the word cosmos to mean an ordered system of planets existing together in harmony. The creation of the cosmos has been imagined in many different ways.

In ancient Mesopotamia, the cosmos was said to have been created after the defeat of the chaos dragon Tiamat. Her body was split in two, with one half forming the earth and the other half the heavens. Chief god Marduk then placed the gods into the sky as planets, stars and constellations.

Chinese mythology tells that the sky was formed from the top of the cosmic egg, which hatched to reveal the creator, Pangu. All the light, pure elements of the egg floated into the heavens to create the stars and planets, while the impure elements sank to form the earth.

Many cultures imagine the cosmos as united by a tree of the universe that stretches between heaven and earth. The Tree of the Universe appears in Indian, Babylonian and Norse mythology.

In ancient Egyptian mythology, the sky was supported by the giant goddess, Nut. Her body was deep blue and covered by stars. It was believed that Nut protected the earth god, Geb, from the weight of the night sky.

Dogon mythology, from West Africa, describes creation as starting with an egg full of potential. The egg began to spin and crack, creating a whirlwind that flung its clay-like contents in all directions. The clay landed in the sky forming stars, planets and spiral galaxies.

The Indigenous American Pima people say that the Earth Doctor created the cosmos. He made the Sun and Moon from balls of ice that he threw into the air. He then blew water into the sky, which formed into many stars.

MYTHS AND COSMOLOGY

People have long looked up to the heavens and wondered what they were formed from, and mythology has provided many possible answers.

Chaos is a popular theme in creation stories and is seen in Greek, Inuit and Mesoamerican traditions. Chaos reflects the state of the universe before the creation of the cosmos brought order. Everything needed to make the world was found within the chaos.

In Japanese Ainu mythology, the universe was formed when some oil rose up from the primordial ocean, caught fire and made the sky. A god was born from the vapour in the sky, and they descended from the heavens on five coloured clouds. Out of these clouds the cosmos was created.

Many cultures describe how the world emerged from churning primordial waters. In ancient Babylon the world could only begin to form after a great battle between the opposing forces of salt water and fresh water.

In Aztec and Mayan beliefs, the world was created and then destroyed by a great disaster. This happened many times and each version of the world had a new Sun. The current world is said to be the Fifth Sun.

Chinese mythology describes a 'breath of the universe', a primeval vapour that contained the two balancing forces of nature: yin and yang. It was from this vapour that the entire cosmos was formed.

THE MILKY WAY

The Milky Way galaxy is home to billions of stars and planets, including Earth! To the naked eye, the Milky Way looks like a ribbon of hazy cloud across the night sky in which no individual stars are visible. This has led to many wonderful stories to explain its existence.

An Indigenous American Cherokee tale tells that one night, an old couple were awoken by a spirit dog munching through their crops. They banged drums and yelled, scaring away the dog. He ran through the sky, dropping corn from his mouth, which formed the Milky Way. In Cherokee, it is known as 'the place where the dog ran'.

The Milky Way is known as the 'Road of the Warriors' in Hungarian tradition. This is because when the Hun army was about to be defeated, the mythical Prince Csaba and his warriors galloped down from the heavens to defeat the invaders. The Milky Way was created by the sparks that flew from the warriors' horseshoes as they rode to the rescue.

In Armenian mythology, the fire god Vahagn stole some straw from his rival god Barsham to feed his people after an especially harsh winter. As he fled through the night sky, some straw fell from his grasp and formed the Milky Way.

In South Africa, Venda and Tswana people describe the Milky Way as a footpath in the sky that the ancestor spirits walk across.

In a traditional story of the Shoshone Indigenous Americans, a grizzly bear climbed up a huge mountain to hunt in the sky. As the bear climbed higher and higher, ice began to collect on his fur and feet. The ice crystals that fell in his wake were said to have formed the Milky Way.

BEYOND THE COSMOS

Cultures from across the world have long imagined otherworlds: places where spirits dwell. Some otherworlds were believed to be the destination of the souls of the dead. Myths and legends describe many ways to reach otherworlds, such as climbing the World Tree or travelling across a magical river.

The Milky Way was said to be the road that leads to the entrance to the Mayan underworld, Xibalba, which means 'place of fright'. To reach it you must pass through three rivers – one filled with scorpions, one filled with blood and the last full of pus!

In the Zoroastrian religion, souls must cross Chinvat Bridge to reach the afterlife. For those who have been evil in life, the bridge becomes as thin as a single reed and they tumble into one of the four hells. For good souls, the bridge is wide and easily crossed. On the other side, they rise past the stars, Moon and Sun to the highest level of paradise.

In Finnish mythology, the earth is a flat disc, at the very edge of which is Lintukoto, a warm otherworld where birds migrate during winter. In Finnish, the Milky Way is called Linnunrata, meaning 'path of the birds', because it was said to guide them to Lintukoto.

The Hindu epic poem Mahabharata describes Prince Arjuna flying in a magical chariot up to the realm of Svarga. This otherworld has no sun or moon, but glows with its own mystical light.

In Slavic mythology, Prawia is the realm of the gods, Jawia the realm of the living and Nawia the realm of the dead. Nawia is a beautiful garden nestled in the cosmic tree. Once a year, souls of the dead can fly back to Jawia in the form of birds, to visit their loved ones.

GLOSSARY

Aeromancy – predicting the future by observing clouds, winds, thunder or lightning.

Afterlife – in some beliefs, a place where people go after they die.

Astrology – the study of the position of the stars and planets, in the belief that they impact human affairs.

Astronomer – someone who studies space and the universe.

Augury – the ancient Roman practice of predicting the future by observing the flight and behaviour of birds.

Aurora – brightly coloured lights that occasionally appear in the sky in the far north or the far south.

Chaos – a state of complete confusion with no order.

Constellation – a group of stars in the sky that form a pattern, often identified with a character from mythology.

Cosmos – the universe as an ordered, harmonious system.

Deity – a god or goddess.

Folklore – traditional beliefs and customs passed down by word of mouth.

Folktale – a traditional story passed down by word of mouth.

Mortal – an ordinary human who is not a god and has no magical powers.

Mythology – traditional stories that are used to explain things such as how the world was created.

Primeval – to do with the very earliest period in the Earth's history.

Primordial – having existed since the beginning of time.

Tradition – the passing down of customs, knowledge and beliefs from generation to generation.

INDEX

Aboriginal Australians 12, 15, 29, 47, 51, 52
Albania 13
Armenia 73
astrology 54-55
auroras 14-15
Aztecs 34, 43, 59, 71

Babylonians 18, 47, 59, 68, 70
Baltic 24, 58
birds 18-19
Bulgaria 48, 63

Celts 10
Chile 48
China 15, 17, 31, 38, 42, 68, 71
constellations 44-45, 50-51
cosmos, the 68-71

eclipses 30-31
Egypt 23, 27, 28, 30, 36, 40, 51, 52, 58, 69
England 19, 38, 62, 65
Estonia 15, 65

Faroe Islands 14
Finland 74

Germany 11, 26
Greece 10, 12, 18, 20-21, 24, 28, 29, 46, 50, 52, 60-61

Hawai'i 37

Hinduism 13, 17, 22, 31, 39, 41, 58, 75
Hungary 72

India 32-33, 68
Indigenous Americans 11, 14, 22, 25, 31, 42, 44-45, 46, 50, 51, 63, 64, 69, 72, 73
Inuit 37, 41
Ireland 19, 24, 38, 48
Islam 54, 59

Japan 16, 25, 36, 70
Judaism 42

Kenya 34
Korea 35

Maasai 55-56
Maya 16, 52, 62, 71, 74
Mesopotamia 10, 68
Mexico 26
Milky Way, the 72-73, 74
Mongolia 52, 65
Moon, the 32-43

Netherlands, the 27
Nigeria 8-9, 17
Norse 12, 23, 25, 29, 47, 49, 68

Peru 43
Philippines, the 35, 66-67
planets 58-59, 60-61
Polynesia 11

rain 17
rainbows 12-13
Romania 64
Rome 18, 39, 60-61

Sami 14
Siberia 40
sky 8-9
Slavic 16, 75
South Africa 34, 41, 46, 52, 73
stars 44-53
Sumeria 51, 63
Sun, the 20-29

thunder and lightning 16-17

USA 19, 38, 65

Venus 55-56, 60, 62-63

West Africa 22, 30, 36, 69

Zodiac 54-55
Zoroastrianism 74